ROBERT INDIANA
AND THE STAR OF HOPE

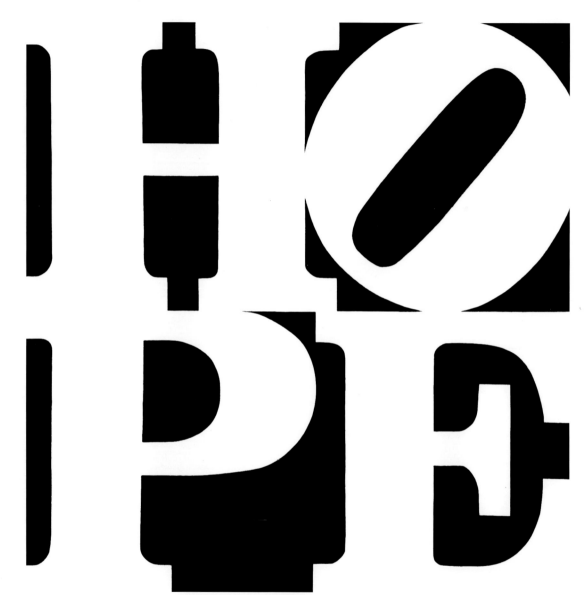

HOPE, 2008, oil on canvas; 36 x 36 ins.; collection of the artist

ROBERT INDIANA
AND THE STAR OF HOPE

with essays by

John Wilmerding

and

Michael K. Komanecky

Published by the Farnsworth Art Museum, Rockland, Maine
Distributed by Yale University Press, New Haven and London

4 Star of Hope Lodge, photo ©Michael K. Komanecky, 2009

TABLE OF CONTENTS

Indiana and Maine: States of Play—Essay by John Wilmerding — 9

The Star of Hope—Essay by Michael K. Komanecky — 33

Artwork — 65

Exhibition checklist — 121

Catalogue index — 125

Director's afterword — 127

Acknowledgments — 128

6 Star of Hope exterior, rear view, ©Michael K. Komanecky, 2008

INTRODUCTORY ESSAYS

INDIANA AND MAINE: STATES OF PLAY

by John Wilmerding

Christopher B. Sarofim '86 Professor of American Art, Emeritus
Department of Art and Archaeology, Princeton University

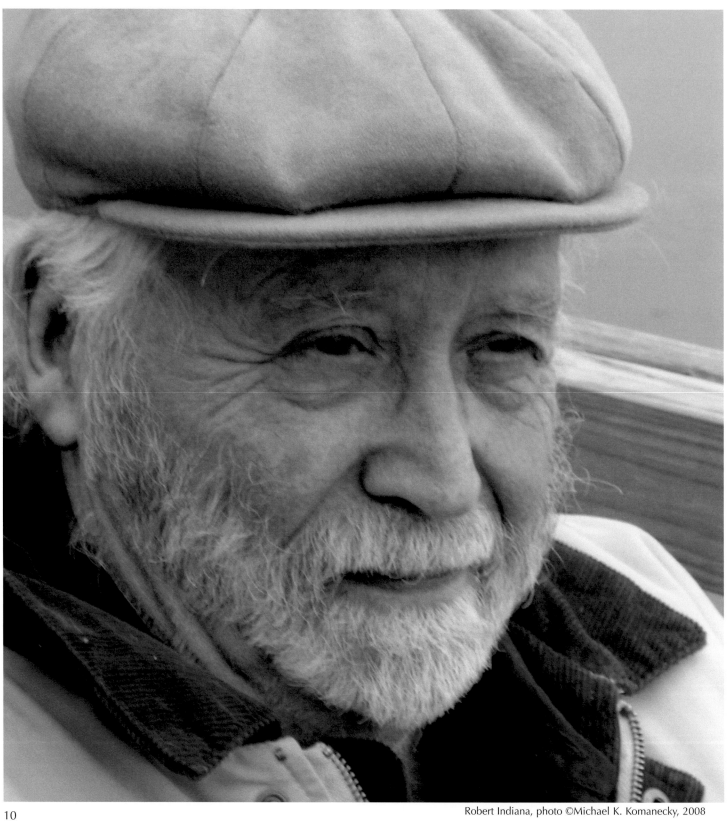

Robert Indiana, photo ©Michael K. Komanecky, 2008

ONE

Robert Indiana turned 80 in '08, a coincidence of personal chronology and visual balancing of numbers he has enjoyed throughout his artistic career. Nearly forty years ago he began summering in Maine, and since 1978 Indiana has lived on the island of Vinalhaven, a longevity contrary to his well-known accounts of moving through some twenty-one houses during his childhood years. Similar contrasts and juxtapositions characterize his temperament and artistic production. There is a serious and brooding side to his personality, along with a clever wit and playful demeanor. There are periods of introversion and moments of cynicism, countered by expressions of outgoing warmth and generosity. We might also note that this artist has learned to live and thrive within the larger rhythms of the year, notably the extremes of Maine's winters and summers.

Indiana's art is also an amalgam of the written and visual, concurrently or sequentially composing both words, numbers, and texts as well as graphic geometries and colors. We are struck, too, by the continuing interplay in his work between the autobiographical and the formal, that is, the deeply personal versus pure design, or put another way, the balancing of strong feeling, even passion, and the mechanical discipline of craftsmanship. Perhaps most noteworthy is the artist's alternate, and sometimes fused, concerns with color versus black and white. These are at once both formal issues but often as well ones of very different emotional expression.

Notable early examples are the contrasting tonal schemes of intense saturated colors in *The Calumet* and *Year of Meteors*, both 1961, counterpointed by the stark black and whites of *The Melville Triptych* from the following year. A much more complex exploration of tonal and graphic extremes occurs in the majestic series of canvases, *The Hartley Elegies* of 1989–1994 (pp. 106–117), dominating Indiana's later career. These bring together the expressive power of both color and black in a dramatic interplay of bright and dark and by implication of life and death. In fact, Indiana has commented on the polarities of positive and negative in his art, that the latter is pervasive and unavoidable in our time, but he hopes the former (codified famously in his *LOVE* emblems) will prevail.

More than most of his colleagues associated with the rise of the Pop movement in the early 1960s, Indiana has been a subtle and persistent autobiographical artist. He not only responded to his environment and time by appropriating the junked materials in and around his Coenties Slip studio in lower Manhattan along with the styles of industrial signage seen around him, but he also infused his work from the beginning with the stories, memories, or incidents of his personal history. These of course have included references to his grandfather and parents, to books he was reading and writers or artists he admired, and in a larger sweep, to issues or events in contemporary American history that particularly challenged him. This polemical side took him beyond the insistent neutrality of core Pop aesthetics, with its obsessive focus on the surfaces of consumer culture and imitation of advertising processes. While Indiana early on removed all trace of his hand in the execution of his paintings, almost immediately his colors and numbers took on specific associational references, as did more obviously the inclusion of words and phrases.

Besides his family and friends, other painters and art critics, his art has taken note of traumatic current events often deeply affecting him.

We need to remember that Pop art arose in the decade of the sixties, alongside the brutalities of Vietnam and the civil rights movements. An ardent pacifist, Indiana variously alluded to deaths in the period, from generals in the military (*Hic Jacet*, 1964) and civil rights marchers in the south (the *Confederacy* series, 1965–1966) to the fallen president (*USA/Perigee*, 1965) and the suicide of America's love goddess (*The Metamorphosis of Norma Jean Mortenson*, 1968). On the personal side a recurring theme has been the artist's own mother's death (*August is Memory Carmen*, 1963) (opposite) and her last words asking if he wanted something to eat (*EAT/DIE*, 1965). Correspondingly, his strong reactions to 9/11 and the wars in Iraq and Afghanistan prompted several canvases of protest (the *Peace* series, 2004).

Such subjects were on the minds of several colleagues at the time, most notably Andy Warhol, who also addressed the darker side of the American dream even as he was gaining notoriety for the blatantly bland paintings of advertising signs and commercial labeling. One thinks, for example, of *129 Die in Jet* and *Suicide*, both 1962, and *Red Race Riot*, 1963, as well as his iconic images of JFK and Marilyn Monroe. The latter two also appeared in mid-sixties works by James Rosenquist, while still others celebrated the lost movie hero James Dean. But Indiana's work remains distinguishable for its persistently personal inflections and the impact of current affairs on the artist's emotional life. As he has frequently said, he has found his own history a continuing area for reflection.

This exhibition and catalogue primarily celebrate the enormously productive and largely unseen second half of Indiana's career, created virtually entirely in the studio on Vinalhaven, and brings to light the artist's own collection for the first time in over twenty-five years. While numerous pieces have gone on the market over the years, and selected major works have appeared in various monographic exhibitions, more have been seen in installations abroad than in America, and until now no comprehensive sense of the later career and its singular achievements has been articulated. At the same time, Indiana has been fortunate to hold on to some of his early masterpieces from the early Pop period, and a number of key canvases and prints from his first decades of production still in his possession are included here to anchor the later work and illustrate the full artistic trajectory.

An almost obsessive cataloguer of his own output, Indiana has been a lifelong collector of archival documents pertaining to his life and work, including articles, photographs, reviews, clippings and posters of all his exhibitions. In addition, he has maintained a comprehensive collection of his extensive body of serigraph prints, numbering in the dozens. Beautiful in their own right, many are important as companions to major paintings, and confirm the vibrant graphic sensibility central to his artistic identity. That all of these materials are housed in the Star of Hope lodge, a Victorian building with its own wonderfully

idiosyncratic character documented in Michael K. Komanecky's essay that follows, provides an unusually rich and complex picture of a major American artist's creative enterprise. In every area of these collections there are revelations to enjoy.

Putting emphasis on the second half of the career is crucial not least because of Indiana's withdrawal from the New York scene, his perceived alienation from the critical establishment and his attendant identity lodged in the first Pop decade of his work. All of this has skewed appreciation, even awareness, of his full career and its evolution to the present. But it turns out that for many of Indiana's colleagues in the Pop generation there has been a widespread lack of attention and evaluation of their later work as most of them gradually moved beyond and away from their original identifiable styles within the movement.

Even the best known of the group, Andy Warhol and Roy Lichtenstein, still tend to be identified and admired most for their initial sixties Pop work, respectively the Campbell soup labels and other printed imagery by Warhol, and the enlarged comic book frames of soap opera girls and heroic combat soldiers by Lichtenstein. For some time following Warhol's death in 1987 his subsequent celebrity portraits of the 1970s were largely dismissed as facile and insubstantial compared to his radical innovations of the previous decade. And we tend to forget that in the eighties he began new experiments with near abstract pictures, like the oxidation, yarn, Rorschach, and camouflage series. These were in part late jabs at abstract expressionism's mythology, but they were also evidence of Warhol's search for new directions and a good distance from his celebrated early career.

Lichtenstein in turn continued to use his Pop vocabulary—the Ben Day dots, primary colors plus black and white, and comic book style—for new and more personal subjects during his later career. Beyond the early commercial imagery of sixties Pop, he began to introduce in the seventies themes of art itself, and even specific reproductions of artwork. Initially, he reinterpreted iconic subjects from the history of art, and especially modern artists whom he admired, like Mondrian, Monet, and Picasso. Over the next decade or so, he redid images by Kirschner, Harnett, Matisse and others. In part, these were puns on replications of reproductions, but they also engaged issues of perception, seeing, and representation in modern and contemporary art. In brief, Lichtenstein reinvented himself throughout his artistic life, with a later career that evolved in fresh ways while retaining basic continuities of style.

Other contemporaries with similarly long careers faced in different ways the challenges of how to move beyond their initial successes without falling into the problems of repetitiveness or self-parody.

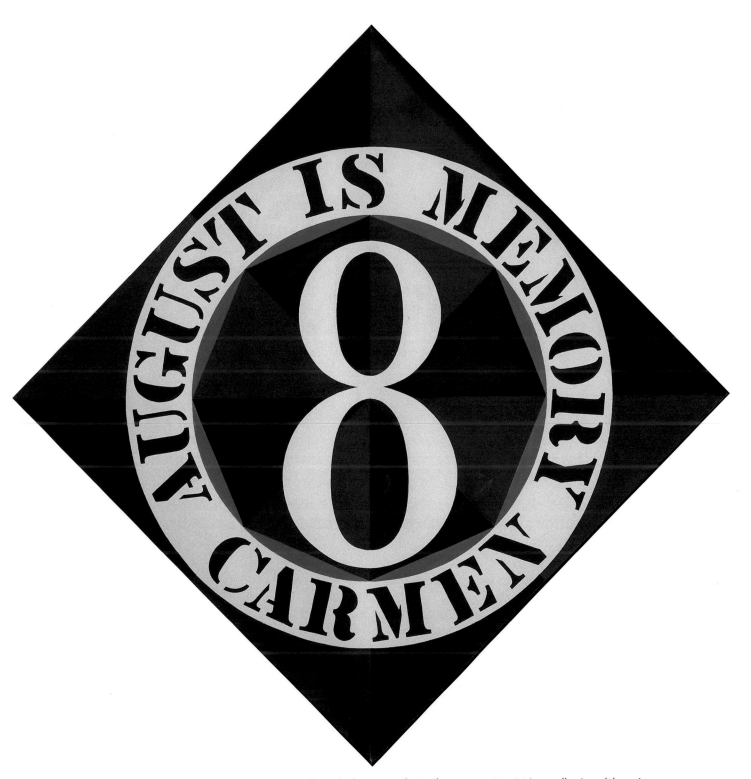

August is Memory Carmen, 1963 (Diamond: Yellow, Black, Brown, Blue), oil on canvas; 34 x 34 ins.; collection of the artist

Of all those loosely associated together in the sixties, Jim Dine perhaps most radically shifted directions in subject and technique after his first Pop art period, with a subsequent more painterly mode of execution and huge canvases of landscape elements. Likewise, still at work, James Rosenquist has gradually applied his slick Pop execution to more abstract and psychedelic compositions.

Claes Oldenburg, much like Lichtenstein, has remained relatively consistent in style, subjects, and techniques. A turning point came when he was able to move from the small-scale plasters of foods and clothing he promoted through The Store in the early sixties, and the many proposals he made in drawings and watercolors for large public monuments. The gigantic *Lipstick* he installed in Bienecke Plaza in 1969 was the first in steady commissions thereafter for huge outdoor sculptures. While he has continued to fabricate pieces of monumental fruits and other ordinary objects, his later career took on new vigor and imagination with the collaboration of his wife and artistic partner, Coosje van Bruggen.

By contrast, Tom Wesselmann of all in the Pop group possibly made some of the subtlest yet most decisive adjustments to the course of his later production. Like Indiana, he never much cared for the Pop designation, especially after mid-career when he clearly began to move in new directions in his work. Known foremost for his *Great American Nude* series, begun in the early sixties and continuing into the seventies, Wesselmann also turned to billboard-scale still lifes based on advertising posters and labels, which earned him the Pop designation. But by the end of the seventies both series had largely run their course, and he began to experiment with different formal and technical ideas. Most notably, he turned to figural shaped canvases, primarily of nudes or parts of figures, and to innovative work in laser-cut aluminum paintings and drawings. Because critics had celebrated his early Pop material, many tended to ignore or devalue these later inventions. Wesselmann was a classic case of an artist who maintained a core continuity in his art, especially the nude which he painted to the end, but who continually reinvented his subject, while also greatly expanding his still life and landscape production.

Robert Indiana has faced many of these same issues over the course of his career, especially the fine line between variation versus repetition. His *LOVE* series of paintings, prints and sculptures is perhaps the most well-known example. To detractors he has probably made too many for his own good. Of course, the ubiquity of the image largely resulted from its almost instant popularity and pervasive replication, all without copyright protection and beyond the creator's control. At the same time Indiana has spoken of his wish for art to be a positive force in the world and his aspiration to place one of his *LOVE* sculptures in every major city around the globe. To this end he has recast the image in a variety of materials, sizes, colors and even languages, some

very beautiful and striking in their effect. Most recently, he has executed an extensive series in different sizes of the word in Chinese, whose first letter happens to begin with I, thus coincidentally tying it in with his own name. Indiana's later career has been a delicate visual dance of variation and reinvention.

Another pursuit of his later work is also evident in several of his original peers in the Pop generation, that of a sometimes conscious, sometimes unconscious, reprise of themes from much earlier work. For example, Lichtenstein in his last years returned to several of his first famous motifs of the sixties, such as the comic book women, fighter pilot images and brushstroke works, which he now redid in his so-called *Reflection* series. These broke up the original pictures with overlaid abstract mirror reflections in clever nearly abstract recollections. Likewise, Warhol in his last years began redoing in new formats and colors the early self-portraits and Marilyn faces, now overlaid in camouflage patterning or in what he called *Reversals*, with the pictures looking like negatives. There was something both retrospective and innovative about these works. Ironically, the year before he died, 1986, Warhol returned to his most famous subject in a new series of *Campbell Soup* labels, but now from packaged soup boxes rather than tin cans, and in a more painterly style of silkscreen execution.

Tom Wesselmann of course had painted the reclining studio nude throughout his life, but the *Sunset Nudes* of his final decade were quite different from the commercialized Pop figures of the sixties. These late works were fresh engagements with the history of art and in particular his artistic dialogue with Matisse. Continuity and reinvention were intertwined to the end. In turn, Robert Indiana has moved back and forth within his own artistic chronology: the *LOVE* and numbers undergo continual refabrication, his *Afghanistan* painting (p. 96) reuses the format of earlier protest canvases in the *Confederacy* series, and his *American Dream # 1* from 1961 led to periodic successors until the final *Ninth American Dream* exactly forty years later. Today, he talks about going back to take up unresolved or unfinished earlier projects, always the master of self-regeneration.

TWO

Fortunately, the Star of Hope collection provides a vivid and nearly complete picture of Robert Indiana's art and life. It includes little reproduced early work, selected major pieces he has held on to from the New York years, and of course, a full panoply of canvases and prints produced over the three decades leading up to the present. Together they reveal their maker's wit and sense of fun along with his seriousness and depth of sentiment. The collection is all of a piece, a complex inter-weaving of autobiography as art and architecture. Even the dense hanging of objects on walls and filling of spaces, from shelves to cabinets and tabletops, have an affinity with Indiana's painted compositions of circles within circles, repeated numbers, and compartmentalized stars.

Just as many of his pictures are based on his personal history, so he has made the building in which he resides and works a form of self-expression. As famous precedents for this, we can think of Frederic Church's Olana on the Hudson, inseparable from each other, or Winslow Homer's spare studio at Prout's Neck, the embodiment of his New England temperament. One might even say that Indiana has also fashioned his own persona: he has enjoyed the repeated telling of anecdotes about his life and art, embellishing and shaping who he is and how he wants to be seen, and like many of his works, both concealing and revealing information, teasing us with the play between surface and depth.

Indiana's biography has been comprehensively documented, thanks foremost to Susan Elizabeth Ryan, and needs no elaboration here.[1] In addition, there is a substantial bibliography devoted to monographic exhibitions, as well as specialized publications surveying most of the media and themes in his art: works in wood, paintings, graphics, the *Hartley* and *Peace* series. The coded gay sensibility in the artist's work has only relatively recently been the focus of investigation, and here most probingly by Michael Plante in conjunction with the *Hartley Elegies* (pp. 106–117).[2] All told, what we learn from these and other studies is that Indiana's art is best understood as an amalgam of both formal and narrative power.

Born Robert Clark in Newcastle, Indiana, in 1928, he has recounted many times the nearly two dozen moves to different houses and schools during his childhood. Showing an early interest in drawing, he finally encountered in high school several teachers in art and support for his inclinations. He later announced that he "loathed mathematics in high school" (though ironically numbers would become central in his art later on), and filled his schedule with art classes.[3]

His first drawings in the forties were often of local street scenes and buildings in the towns of his youth, for example, one showing his cousin Jack McDonald's general store in Beanblossom, another showing the view across the street from his grandmother's house, including the school where John Dillinger had gone. This painting he remembers selling for $10. (He recently repurchased it on e-Bay for $6,000.)[4] As his talent developed, like many aspiring painters, he began to study carefully and emulate some of the prominent artists of the period. Several of these were well-established figurative painters from the 1930s known for celebrating regionalist scenery and subjects. Among them were John Steuart Curry, Reginald Marsh, and Edward Hopper, whose respective styles can be seen inspiring such watercolors by Clark as *Woman on a Bus* (p. 66), *High Yaller* (p. 16), and *Barns on a Hillside*, the latter set in Indianapolis near his last home in the state. Following a stint in the army, Clark was encouraged to enroll on the G.I. bill in the art school of the Art Institute of Chicago, where he flourished into a fully trained artist. His next aspiration would be the art world of New York.

After travel to London, Clark returned to settle in New York in 1954. A job selling art supplies soon put him in contact with other young artists, including James Rosenquist, Charles Hinman and Ellsworth Kelly. Through mutual contacts they and other painters found living and loft spaces in several of the mostly abandoned warehouse buildings along the lower Manhattan waterfront. Jack Youngerman and Agnes Martin occupied nearby studios in the buildings at Coenties Slip, and the older Louise Nevelson also worked in the area. This loose community of friends shared the energy of facing the dominant art movement of the day, abstract expressionism, and they gradually developed their own new styles of hard edge abstraction.

Another part-time job at the Cathedral of St. John the Divine would lead to the artist's largest and most important work to date. About this time, on the threshold of ambitious new work in a new environment, Clark determined to create a new artistic identity and name for himself. Concluding that Clark was almost as common as Smith or Jones, he assumed the name of his native state, Indiana, and declared that he would be an American painter of signs. This was an assertion of emphatic nationality to counter the perceived European underpinnings of abstract expressionism then prevalent. It was of course also in the long tradition of other American painters and writers who took on the mantle of a new artistic identity often at the outset of a career. One thinks not only of Walt Whitman, one of Indiana's heroes, but also Mark Twain, Fitz Henry Lane, Arshile Gorky, Robert Henri and Mark Rothko.

At the cathedral the young artist had employment typing correspondence for Dean James A. Pike, who also introduced him to selections of theological literature. Out of this came the idea for a mural-scaled work called *Stavrosis* (Greek for crucifixion) (pp. 72–73), structured around several large cross-shaped forms. While the lateral composition of mostly grays, blacks and whites vaguely suggests the architectural vaulting and windows of a gothic church wall, it also has the bold graphic flatness of a billboard, and hints of the direction Indiana's work would soon take. Originally executed in printer's ink on paper (and subsequently mounted on wood), the imagery retains a sense of the artist's brushwork and thinness of the liquid medium. The next step for Indiana would be more strictly balanced designs and sharp hard-edged outlines. At the same time, within this large grid he has incorporated other organic motifs of interest to him at the time, such as the avocado seed and the doubled gingko leaf.

These organic shapes directly related to the work of his friend on Coenties Slip, Ellsworth Kelly, who was perhaps the closest personal and artistic influence in his life at the time. Kelly had spent several years in Paris developing his own art from observations of plants and fruits, which resulted in large simplified line drawings. Another group of pictures were distillations of architectural subjects like bridge arches,

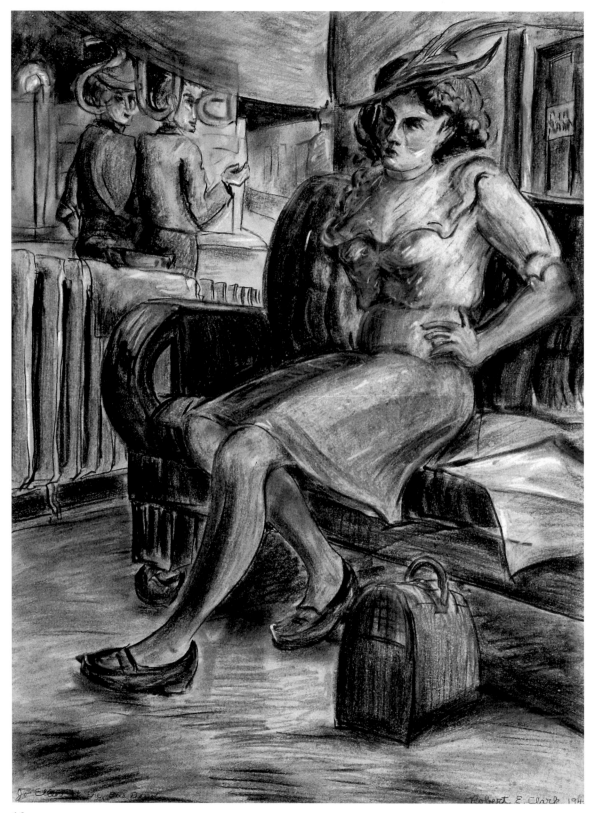

High Yaller, c. 1945, watercolor, gouache and graphite; signed in ink at bottom: "Jo Ellen & The Bus Depot"; 23 1/4 x 17 1/2 ins; collection of the artist

windows, doors, roofs or steps. Once back in New York, Kelly moved towards even more abstract geometric reductions of these themes with silhouetted and angled planes of color and suggestive plant-based forms. Jack Youngerman was also producing paintings of leaf-like designs with increasingly hard-edged contrasts of figure and ground.

Key early pictures still in Indiana's possession show these obvious mutual artistic interests, for example, a series of silhouetted circles he called *Orb* paintings (pp. 76–77), his first renderings of the double gingko leaf, and a large avocado image in Kelly-like blue, green, and black he titled *Source I* (p. 74). Although gesturalism and painterliness had largely been effaced from these works, there are affinities nonetheless with the biomorphic precedents in abstract expressionism, especially Robert Motherwell, early de Kooning and Rothko, and Adolph Gottlieb. Indiana had to paint many of his first works on homasote, a cheap board compound, since he couldn't yet afford canvas.

Another unusual set of paintings from the late fifties were titled *Mene Mene Tekel* (p. 70) and *Tekel* (p. 71), and also involved strongly silhouetted forms against bright backgrounds, in this case silver and gold tones respectively. These totem-like heads recall several precedents. We can see echoes, for example, of Russian Byzantine icons and trecento Siennese religious figures. One single figure has flat frontal features not unlike an Egyptian Fayum or Pompeian head, but was in fact undertaken as a portrait of the artist's friend Paul Sanasordo, a dancer and former student at the Art Institute. Indiana then owned (and still owns) a group of mounted wooden heads, possibly African, similarly elongated and rounded, which were clearly a partial stimulation.

The single words interspersed on the background between the repeated shapes of three heads are later additions, inspired by Marsden Hartley's late painting called *Fishermen's Last Supper* (private collection). In the summer of 1938 this early American modernist came to Vinalhaven to paint, after having spent time living with the Mason family in Nova Scotia. Hartley had become passionately attached to two of the sons, who were tragically drowned at sea, and painted several pictures as memorials.

In this first version of *Fishermen's Last Supper* the family is lined up at the table, and on the white wall behind, are stars over the lost fishermen. On the table cloth in the foreground between the empty chairs appear the words "MENE ... MENE," taken from lines in the Old Testament Book of Daniel referring to God's handwriting on the wall. His message warned of doom for the defiant King Belshazzar, and seemed apt to Hartley for the proud lost Alty Mason.[5] The composition of course also recalls Leonardo's and other classic *Last Supper* images. Friendship and loss were shared themes for Hartley and Indiana, who as we know would engage Hartley's life and art in much greater depth with the *Elegies* series. Now as Indiana settled in

on Vinalhaven himself, he found especially poignant that Hartley had painted his memory image practically across the street from the Star of Hope.

But well before this later transformation of the work, these primitive heads and richly textured painting surfaces were initially grounded in the abstract practices of the 1950s. We have already noted the influence of EIlsworth Kelly as the first shaping force in the development of Indiana's style. Their artistic and personal closeness came to a head around 1960. Symbolic of the friendship and its breakup around this time is one of Indiana's most abstract paintings (though he doesn't like his art to be called abstract), *Easel*, 1960. This was in fact a depiction of Kelly's painting easel, which he gave to Indiana at the time. This sign of intimacy made the picture a metaphorical portrait of his friend. The easel frame in bright Kellyesque red perfectly balances the white open areas within, thus fusing figure and ground in one plane.

But Indiana must have felt he was flying too close stylistically to his colleague's work, and made the move to an independent course by deciding to introduce words and text into his compositions. He claims Kelly would not forgive him for the shift in direction, and a parting of the ways followed. With rare exceptions Indiana would incorporate numbers, letters, words or phrases into his designs for the rest of his career.

Kelly's influence, however, was decisive in setting his friend's work on its new course in a flat hard-edged style. But the organic curves of Kelly's plants and the cropped planes of his architectural elements were transformed in Indiana's hands into full geometric motifs with no derivation in nature. His imagery would be more purely graphic, in part inspired by commercial design and printmaking, and in part by the rise, alongside Pop art, of minimalism and op art, which also indulged in the rhythmic repetition of geometric forms. In fact, Indiana's signature style came to occupy an independent middle ground between Pop and minimalist painting. For instance, we can see certain affinities in his work on the one hand with James Rosenquist's billboard subjects, and on the other with the clean geometric *Protractor* canvases of Frank Stella.

Indiana's typography, although obviously indebted to the language of advertising and commercial design, employed stenciling with such clarity and creativity that his letters soon took on a distinctive and uniquely recognizable look that has been widely imitated throughout American culture. One of the important early works in this newly personal and identifiable style still held by the artist is *Columbus: The Geography of the Memory* (page 18). It represents many of the central themes and compositions Indiana favored not only in this defining first phase of his mature career but intermittently in his art to the present.

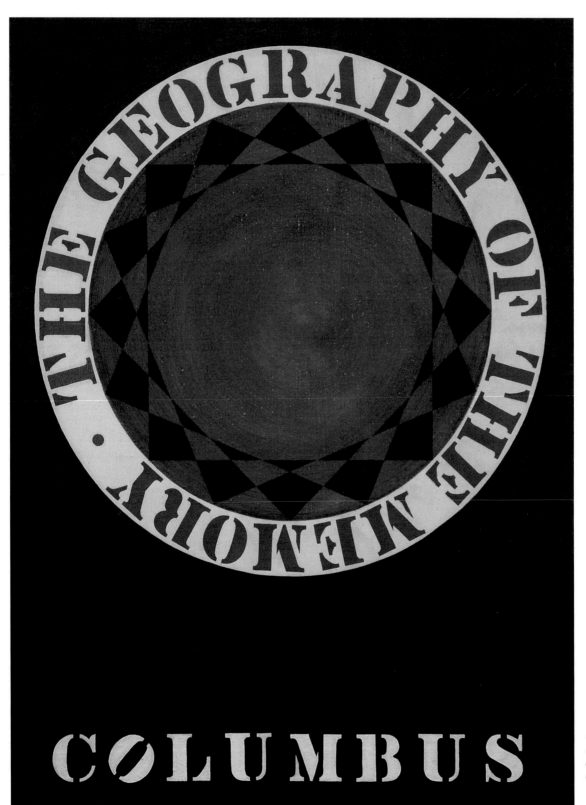

Columbus: The Geography of the Memory, 1960–1992, oil on canvas; 42 x 31 ins.; collection of the artist

First, the words of the title refer to history, place, and personal recollection, all subjects that would regularly inspire Indiana's art. Columbus was a city in Indiana, named of course after the explorer associated with America's discovery. Further, the main color of the canvas, brown, had associations both with the state and with the artist's life. As he said in reference to another autobiographical painting of this time, *The Sweet Mystery*, 1960–61, "my father's last property in Indiana was on Greasy Creek in Brown County."[6]

Over the next few years the artist made cities in his native state a subject of several other canvases, no doubt arising out of his memories of moving so frequently to different towns during his childhood, the most notable being *Terra Haute*, 1960, *New Castle* and *Terra Haute #2*, both 1969.[7] Appropriately, all three of these make use of varying shades of brown, as does another related painting of 1963, *August is Memory Carmen* (p. 13). Here the citation is to the artist's mother, who died in the month of August, a memory that will surface repeatedly in various ways for Indiana.

In addition, the format of *Columbus* established a geometric design that would become one of the artist's favorites, that is, the circle set within a vertical rectangle. With a passionate intensity he explored its possibilities as perhaps the dominant composition in his work of the early sixties. In some instances the circles embraced images like stars or a boat, as in *Red Sails*, 1962, and *The Triumph of Tira*, 1960–61; in others, words filled the circles, for example, *The American Sweetheart*, 1959, and *EAT/DIE*, 1962.[8] Indiana was also producing sculpture in this period, mostly out of old wood beams he found in the spaces of neighboring abandoned warehouses. These he called herms after ancient Greek precedents, and often attached to them iron wheels, also left over as parts from the age of sailing and steam ships. Their circular forms often played off related round images, as in *HOLE* or *MOON*, both 1960.[9]

In the case of *Columbus* we have actually two concentric circles, with the title phrase set around within a design Indiana employed in at least a dozen canvases in these years, from *The Slips*, 1959, and *A Divorced Man Has Never Been The President*, 1961, to the *Confederacy* series of 1965 and *The Metamorphosis of Norma Jean Mortenson*, 1967. Repeated circles link three of Indiana's best known early paintings dedicated as homages to great writers of the American Renaissance of the mid-nineteenth century, *The Melville Triptych*, *Year of Meteors* and *The Calumet*, all 1961, incorporating lines respectively from Melville, Whitman and Longfellow.[10]

While Indiana would also make use of the square and its variant the diamond, as well as occasionally cross and X-shaped compositions, the circle had special appeal for its formal purity and multiple thematic associations. Like the square, it was one of the most basic

geometric forms, and perfectly served this artist's instincts for centered and balanced designs. But the circle was also nearly indistinguishable from the number zero and all its connotations. Even more, the number 0 is unique in being almost interchangeable graphically with the letter O. Thus, the circle's capacity for expressive visual and literary impact.

In her poetry Emily Dickinson made extensive use of the circle as emblem: for the eye, the self, for the cosmos. The form of course suggests the globe and the solar system. We remember that Melville in *Moby Dick* began with the circumambulation of the island of Manhattan before extending his literal and metaphoric voyage out to circumnavigating the hemisphere out to the Pacific. As an aside, notice how the O in *Columbus* is split in two and tilted like the hemispheres of the globe. As zero, the circle is omega but also suggests the constant recycling of endings and beginnings. No wonder it would serve Indiana so well from its first imperfect appearance in *Source*, 1959, to *Hallelujah (Jesus Saves),* 1969 (p. 91), and *The First State to Hail the Rising Sun*, 2002 (p. 124).

THREE

Rarely has Indiana executed the circle as a finished form in itself. Normally, his circles appear within rectangles or, less frequently, diamonds. There are two major exceptions, one early in his career and several later. In 1963 the architect Philip Johnson commissioned a group of contemporary artists to complete works for display around the exterior of his New York Pavilion at the 1964 World's Fair. Indiana created a large piece in steel that was hung between works by Ellsworth Kelly and Robert Rauschenberg. Nearby were contributions from Andy Warhol and Roy Lichtenstein. It was a provocative and assertive display of the newly triumphant Pop art movement.

Indiana chose to design a construction of five metal circles arranged in a railroad crossing X, with the word EAT spelled out along each axis (p. 104). Outlining the capital letters were small light bulbs, creating the effect of reflector letters on interstate highway signs. In this and a second version of *EAT* with the three letters within one circle he had the bulbs flash on and off rhythmically, appropriately calling the later one *Electric EAT* or *Jitterbug EAT* (p. 90). In such works Indiana was introducing new elements into art making that were just beginning to interest other contemporaries like Chryssa, Bruce Nauman and Dan Flavin.

But when illuminated, Indiana's lights spelled trouble, and Fair officials soon ordered them turned off. They claimed the public would be misled into thinking the building was a restaurant, not the cultural and art pavilion it was. (Even more notorious was the fate of Warhol's huge canvas depicting *Thirteen Most Wanted Men*, based on police mug shots. Fearing lawsuits, since the criminals had not yet been convicted, and disapproving of the offensive tastelessness, the organizers asked

Warhol to remove his work. He refused, and instead covered the surface with silver paint.) Indiana's assemblage was returned to him when the Fair closed, and remains one of the most dramatic public works he created still in his possession.[11] It is on view here for the first time since the Fair.

The idea for imagery of single three-letter words was one Indiana had already worked out in the preceding couple of years. For example, *The American Sweetheart*, 1959, consisted of twenty small circles, each containing a three-letter girl's name. *The Triumph of Tira*, 1961, displayed in a dazzling mixture of simplicity and complexity each of its four words within the successive frames of a star, circle, square and circle.

In a 1962 pair of canvases for the first time he juxtaposed *EAT* and *DIE* side by side within circles inside squares. These minimal verbs and nouns belonged to the rising lexicon of advertising commands and statements seen in consumer culture from billboards to cereal boxes. In this instance, the words additionally signified the larger theme of life and death, especially on the American road. After all, this was the age of the new interstate highway system, in tandem with the flourishing of inexpensive motels and chain restaurants, together giving us fast cars, fast foods and fast sex. The word die was also a single dice, reminding us that deaths on the highway were often sudden and unpredictable.

Indiana played with this double entendre further in a phrase, *The American Dietary*, that he used in another canvas. Also in 1962 he reworked his linkage of *EAT/DIE*, in which the circles were centered within diamond formats. Presumably, the death component and its treatment in black would not suit the mood and occasion of the World's Fair. Moreover, this pairing was finally very personal, for the artist has often recounted his mother's last words asking whether he had had something to eat just before she died. By centering on *EAT* alone he made his sculptural relief appropriately public and communal.

There are other interesting and iconic works worthy of note from the early 1960s saved in the Star of Hope collection, among them two with Indiana's characteristic interest in national design or emblems: the *New Glory Penny* (p. 21) and *New Glory Banner,* originally done as a work on felt in 1963, and revisited by Indiana as a painting in 1999 (right). The first imagines how Betsy Ross might have reworked the flag into a vertical rectangle of red and white stripes with a blue circle of white stars centered in the upper half. This new symmetry makes possible the display of the design either in a vertical or horizontal alignment. But for Indiana it is not just formal playfulness at work. Given the backdrop of the late sixties, he also saw this as an anti-war picture. If one sorts out the optics of the star field, the eye can discern concentric pentagon patterns in the stars' alignment within the circle,

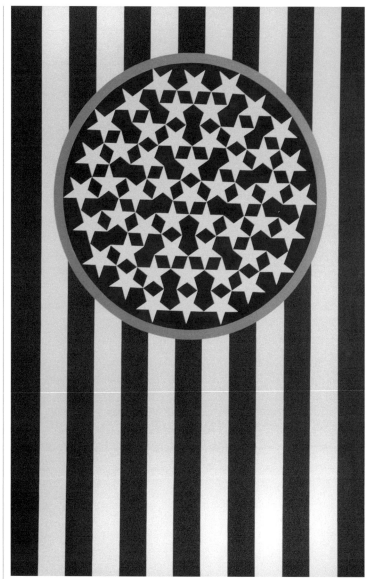

New Glory Banner, 1999; oil on canvas; 91 1/2 x 60 ins.; collection of the artist

and a count of their number reveals a total of fifty-one. For Indiana the rhetorical question was, in America's empire building, would Vietnam or some other territory become another national annexation. The publishing company Multiples subsequently gave this image wide visibility through the fabrication of a reproductive banner.

The penny with its number 1 and star on recto and verso, enclosed in a ten-sided form, was intended to be readily identifiable by touch or sight in the user's pocket change. It came into being in response to an invitation from the magazine *Art in America* to ten American artists to propose new designs for United States currency. Not surprisingly, these

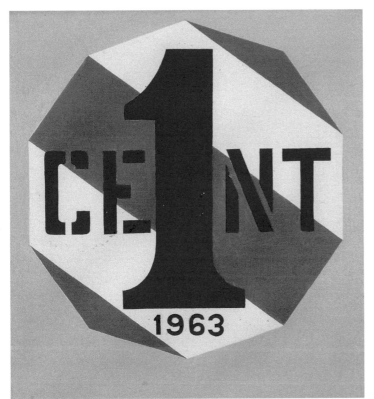

New Glory Penny (diptych), 1963, oil on canvas;15 1/4 x 13 ins. each; collection of the artist

bright imaginings never made headway into the world of bureaucratic function, though Indiana's proposal did make the art magazine's cover.

Perhaps the most important autobiographical work from the early career to remain in the artist's hands is *Mother and Father* (pp. 22–23), two pendant canvases painted largely in gray, filled with tondo compositions, and beneath the respective circles the inscriptions "A Mother is a Mother" and "A Father is a Father." The tautological title naturally brings to mind the repeated phrasing of one of Gertrude Stein's best-known verse lines, "A rose is a rose is a rose." Indiana began this project in 1963, intending to complete three additional versions, each to be set in one of the four seasons of the year. He painted this first pair of his parents in the raw period of winter with the trees bare and almost no color. Incongruously, the figures stand out in the cold, partially undressed, next to the family automobile.

The car was a reminder of all those early years of constantly moving, and Indiana likes to think of himself as possibly conceived in its back seat, hence the 1927 license plate from the year before his birth.[12] His partially clothed parents are preparing for sex. Only the mother appears surrounded in bright, suggestively erotic, colors, with her breasts exposed invitingly to the viewer. Other historians have noted

that she was one of a sequence of wives his father married, as if each was a disposable commodity.

The figures are posing as if for a photographer, a notion enhanced by the forms and color scheme of the canvases. Side by side, they look like stereopticon photographs or old tintypes mounted in an album. The openings could either be lenses or our eyes peering through a pair of spectacles. Circles dominate: the mother's breasts, the wheels, head lamps, even the hood ornament. Furthermore, when hung together, the two touching circles recall the reproductive aspects of the flowering gingko leaf from a year or two before. While the license plate on the father's side indicates this canvas was completed in 1964, Indiana labored on this project for nearly four years. Their unusually large size and complexity drained his energy, and he wryly explained that pursuing the other seasonal versions might prove problematic even for the contemporary mores of the sixties.

Over the course of the seventies Indiana broadened his verbal and numerical imagery. In the preceding decade he had created some of his great iconic pieces, including *The Figure 5* and *The Demuth American Dream #5*, works he considers among his best. These were tributes to the pioneering early American modernist Charles Demuth,

21

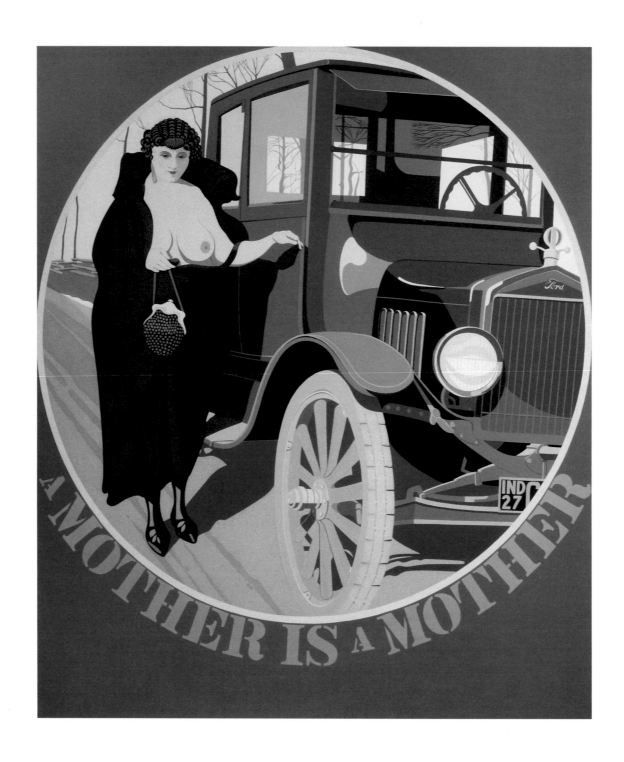

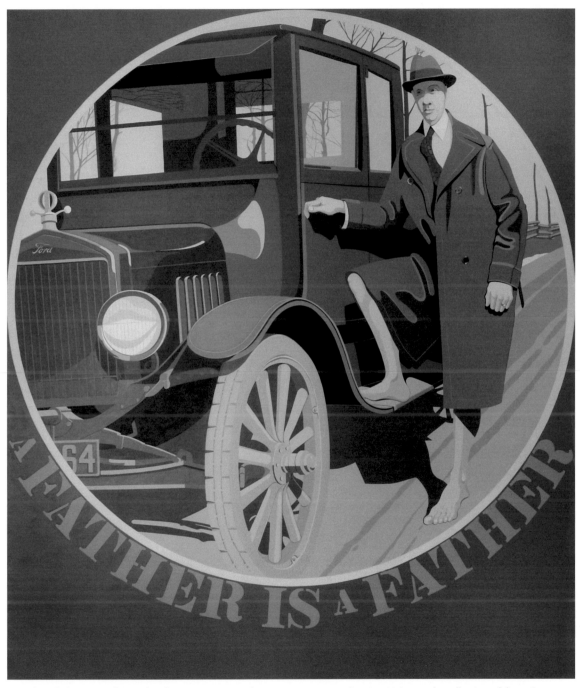

Left and above: **Mother and Father**, 1963–1967, oil on canvas; two panels, 72 x 60 ins. each; collection of the artist

one of several in that generation of the abstract avant-garde whom Indiana admired. Demuth made pictorial homages to Hartley, as we have noted, and to Gertrude Stein, Joseph Stella and Hart Crane. Indiana's *Demuth* series all centered around the repetition of number 5, originally inspired by the short poem of William Carlos Williams, "I Saw the Figure 5 in Gold," which in turn led to Demuth's painting of the same title. When Williams wrote his lines, he was on his way to visiting Hartley's studio, thus tying together several of the key figures in the Stieglitz circle with whom Indiana felt a kinship.

Besides the literary, artistic and personal associations embodied in the Demuth tribute, the shape and significance of numbers had also increasingly engaged Indiana's imagination. Their graphic silhouettes had interested him almost from the beginning, both singly and sequentially. One of his first series was *Exploding Numbers*, 1964–66, shown prominently at the Montreal Expo in 1967. These played both on the arithmetical progression of one to four and on the geometric increase in the canvas sizes across the wall.

In 1968 he collaborated with the poet Robert Creely to publish a book of poems with the lines about each numeral facing Indiana's color serigraphs. This series consisted of the first ten single numbers running from one through zero. Now they began to take on associations with the calendar and the passage of time, a mathematical voyage of life, whether marked by seconds, minutes, hours, days, weeks, years, seasons, or stages of human life. Now the colors changed through the series, moving from cool beginnings to increasing vigor and intensity and eventually to the loss of color in the blacks and grays of night, winter and old age.

At the outset of the seventies Indiana began a more explicitly autobiographical numbers series, which he called *Decade: Autoportraits* and was dedicated to each of the years in the preceding decade. These were more complicated visually, with intersecting planes of colors, numbers and words referring to places, names or works of art significant to him at each juncture. Among the large number paintings he has held on to is *Beethoven* (p. 99), in this instance celebrating the great composer's culminating symphony. The combination of lavender and yellow colors suggests its lush romantic character, while the black lettering suits the work's place at the end of the musician's life. Indiana has said he has always worked with music playing in the studio, and enjoys various artists from Mozart and Prokofiev to the folk singer Richard Dyer-Bennet.[13]

Periodically in his career Indiana has had projects or commissions rejected. On such example from these middle years was *She He* (right), in design not unlike the *Decade: Autoportraits*. The pendant format of course well suits the gender pairing, but more pointedly the

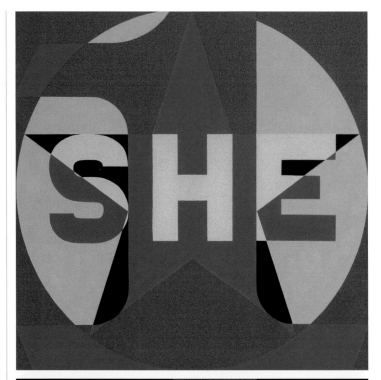
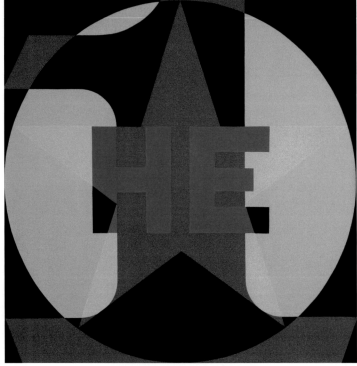

She He, 1970s; oil on canvas; 36 x 36 ins. each; collection of the artist

lettering incorporated the initials of the patrons' first and last names, Herold and Sonja Eiteljorg. Indiana knew them from Indianapolis, where the husband was prominent in supporting the museum dedicated to native American art. Unhappy for some reason with the artist's efforts, they did not accept the paintings, which have consequently remained in his collection.

One of Indiana's most ambitious projects came in 1976 with a commission from the Tyrone Guthrie Theater in Minneapolis to create the sets and costumes for an opera, *The Mother of Us All*, in celebration of the national bicentennial. Called *An American Pop Opera*, its narrative was based on a Gertrude Stein text, itself "filled with names and name changes. It was right up my alley," as Indiana said.[14] Even more, he found irresistible the name of the lead female character, Indiana Elliot. A panoply of figures from American history had roles in the story, including John Adams, Susan B. Anthony and Daniel Webster, and for over a decade Indiana worked on costumes and backdrops with motifs of flags, banners, and eagles.

After opening in Minnesota, the opera then went to Santa Fe, where it was accompanied by fireworks. Although the costumes were made of felt, they proved quite suitable for the cold summer nights in the high desert. Only a few performances were scheduled, including one (to the artist's great pleasure) with Georgia O'Keeffe in attendance. At the conclusion of the run, Indiana wistfully recalls, the manager had all the sets moved outside the back of the theater, where they were burned. Fortunately preserved at the Star of Hope are some two dozen full watercolor studies for all of the principal figures and two detailed collages for the leads . Interesting and vivid in their own right, they also remind us of the rich variety of media and imagery held together in the Star of Hope collection.

FOUR

By the end of the 1970s Indiana was tiring of New York. Dealers and the art establishment were not treating him well, and circumstances soon offered a major opportunity for change. In 1968 he first spent time in Maine, on a summer scholarship at the Skowhegan School of Art. Subsequently, a friend, Eliot Elisofon, invited him to visit Vinalhaven. Elisofon was a prominent staff photographer for *Life* magazine, one of the artist's favorite publications for its distinctive publication of art reproductions. On a trip in 1969 Indiana got his first look at the Star of Hope lodge on Main Street, an imposing three-story Victorian building with great character.

It was a wrenching move from the Bowery for the artist, taking twelve trips with two vans to move all his art and possessions. He was cutting himself off from colleagues and friends to live and work in a new landscape and climate. As we might expect of such a break in mid-career, there would be both continuities and shifts in his work

over the next three decades, much of it neglected by art critics and unfamiliar to the public.

Though more physically isolated and alone than in New York, Indiana remained fiercely attentive to the world and as engaged in history's affairs as he always had been. In this regard he was not unlike his famous predecessor Winslow Homer at Prout's Neck, where isolation ultimately provided a new universality and grandeur in his art. We are also reminded of other Maine painters who came to remote areas of the coast for solace and inspiration, most notably John Marin, Rockwell Kent and Marsden Hartley, during the later years of their lives. The latter in particular would soon enter Indiana's emotional and artistic life in a crucial way.

Of all the continuities in Indiana's art, his overarching signature image, and the most famous, has been his LOVE design, which also has connections to the early American modernists. In another poster portrait, Charles Demuth paid his tribute to Gertrude Stein in a painting with LOVE stenciled three times across the composition. While its first incarnations in Indiana's work date to the mid-sixties (and have been widely imitated and misappropriated by others since), it has undergone extensive transformations from paintings and prints into sculptural versions in recent decades (pp. 78, 79, 80, 81, 103).

Most notably over the second half of his career he has fashioned the LOVE block in a range of sizes, from tabletop to architectural scale, in a range of media (including wood, marble, corten steel and brushed aluminum), and with numerous painted finishes in his favorite color combinations. More recently Indiana has executed the sculpture in other languages—first *AMOR* and the Hebrew *AHAVA* (p. 80), and lately, painted versions in Chinese (p. 103), these last done in a combination of that country's national colors, red and yellow. These were especially felicitous, since the Chinese word for love is Ay, which of course rhymes with the first letter of the artist's name. Indiana has since completed designs as well for *PREM*, the Hindi word for love.

The idea for the *LOVE* first emerged, Indiana has recalled, in a small painting from the early sixties with four stars arranged in a square on a blank field and the word LOVE stenciled below. Serendipity stimulated a reworking in 1965, when the Museum of Modern Art commissioned a Christmas card by the artist, who conceived of arranging the four letters in the square format. The colors he chose were ones with autobiographical associations. Red and green were already connected to the holiday season, but also happened to be the colors of the Phillips 66 gasoline stations of Indiana's childhood. The blue represented the sky he remembers seeing behind the elevated signs.[15] He enjoys retelling the fact that the card proved to be MOMA's best selling card ever, and remains a popular seller today.

Another continuing subject from the later sixties to the present, of course, has been the numbers series, again first in painted versions and print editions followed by metal sculptures in graduated sizes. The numbers in their sequential color combinations have an exhilarating emotional resonance and continue the idea of seasonal change, while the neutral surfaces of the metal editions appeal more for their varied textures, and call attention to the formal clarities of their silhouettes, animated especially in different urban or natural settings.

But it was a new series of works, the *Hartley Elegies,* begun after several years on Vinalhaven that is one of the great achievements of Indiana's later career. Soon after settling on the island, he discovered that one of the foremost early American modernists, Marsden Hartley, had lived there in 1938, in a house nearby the Star of Hope lodge on Main Street. The fact that Gertrude Stein had called Hartley the greatest American artist in Paris at the time only piqued Indiana's interest. It led to his renewed attention to the great Hartley painting, *Portrait of a German Officer,* 1914, in The Metropolitan Museum of Art, one of several abstracted so-called poster portraits of his friend Karl von Freyburg killed early in World War I.

Beginning in 1989 and continuing for five years, Indiana undertook a sequence of some two dozen large canvases in tribute to his predecessor. For Indiana they were in part about his own similar losses and recent separation from friends in New York, and about isolation on the Maine coast. Historians have further pointed out that both men were on the move in childhood, modified their names as artists, wrote poetry, shared the conflicts of sexuality, and produced original autobiographical expressions.[16]

Hartley's work also provided important avant-garde examples of bright flat colors, emblematic fragments of words, letters, and numbers, and an expressive art of passionate feeling. There are of course important differences between the two artists: Hartley's paintings relate to cubism and German expressionism. They are modest in size and textured in brushwork, whereas Indiana's are mechanical, self-effacing in execution, and of the scale of commercial sign painting.

Indiana began the *Hartley Elegies* series by first closely interpreting the Metropolitan picture. While the composition appears abstract, its vertical format framing an upright figure partially defined by the paraphernalia of a uniform, with a strong circle enclosed by a triangle, help to suggest a portrait type. He follows the components of the original fairly directly, and repeats the basic color scheme of red and green, black and white, blue and yellow—all classical color complements.[17]

Hartley had included various references to his soldier companion—the World War I Iron Cross awarded to him just before his death, his initials at lower left and age to the right, his regiment number 4 at center,

along with other designs indicating tassels, epaulets, banners, and flag, plus the letter E referring to the Queen of Greece, his own first name (Edmund), and perhaps the subject of elegy itself.[18]

Beside scale and the hard edge execution, Indiana integrates a strong large circle with lettering into his version. Now he spells out the German officer's full name, the year of his death and the date of his painting. As the series proceeds, a number of overlapping histories from the early to the later twentieth century come together in the imagery. Indiana begins to interweave his own life as part of his response to Hartley's work. The next canvases elaborate on parts of the original color scheme, one in red, white, and blue, another in red, yellow and black, the national colors of America and Germany. This juxtaposition finds verbal equivalents in the introduction of President Kennedy's famous line delivered before the Berlin Wall, "Ich bin ein Berliner," followed by "the American painter" in German. The resonance of Berlin at two historical moments adds national to personal meanings for Indiana.

In addition, the checkerboard design with its gaming associations for Hartley and von Freyburg now gives way to a stars and stripes pattern, and the tips of rockets appear in the upper corners, relevant to both historical periods. The next vertical canvases radically change coloring, one without color in muted grays, whites, and blacks, a second introducing purples. Buried in the lower right quadrant of the former are the small initials TvB, who turns out to be an artist neighbor of Hartley's, Theodore von Beck, with a studio and residence next door overlooking the harbor. But generally instead of individual names there now appear the places meaningful in either Hartley's or Indiana's life: New York and Berlin where each worked, Lewiston and Ellsworth where Hartley was born and died, and Vinalhaven. (Some have suggested that Ellsworth could of course have had a dual identity for Indiana, the city in Maine and his early New York friend.) The words "Truth, Friendship, Love", borrowed from the motto of the Odd Fellows in whose former lodge Indiana now lived, introduce abstractions poignant to both painters.

A sixth vertical canvas is even more radically reductive in its stark patterns of black and white (p. 117). Three repeated 8s have connotations of eternity, but are also a favorite Indiana number in being the month of his mother's death and rhyming with the passive of eat, one of her last words before expiring. Having fully explored the possibilities of Hartley's original format, Indiana then turned to five variants in a diamond and six in a tondo form.

The large circle he had introduced at the outset fills the diamond compositions, and most of the emblematic details and words of the original design reappear, but in completely new formal arrangements, with circle variations tending to dominate. Indiana

made full-scale prints from all of these first two groups. The final sequence of half a dozen tondo arrangements were distinctive in their own right. It would be easy to say that these were primarily reworkings of the earlier circles, no longer framed by other elements or geometries. While the numbers and crosses are still present, these are without any words or phrases.

After several years of working on the *Elegies*, Indiana said he reached a point of exhaustion. "Enough was enough," he recalls. The tondo canvases were particularly challenging to stretch and mount, and his formal explorations had reached their limit. Altogether, they were among the most complex and visually dense paintings of his career to date. They contained perhaps subliminal echoes of the great twentieth-century traditions of cubist fragmentation and expressionist color, from Picasso to Kandinsky, yet were unabashedly American and modern in their exuberance and central place in the contemporary currents of op, minimalist, Pop, and color-field painting. Their initial inspiration in Hartley enriched Indiana's own introspective ruminations, but above all proved to be a cathartic revitalization of his creative imagination and production for much of his work since.

There have been other continuing series of works, both in paintings and sculpture. Instead of being produced in an intense continuous period, like the *Hartley Elegies* in the early nineties or the *Peace* paintings a decade later prompted by the wars in Iraq and Afghanistan, these were themes to which Indiana turned intermittently over many years. One was the subject of *The American Dream*, which exists in nine versions and has had special meaning for the artist. The title came from a play by Edward Albee, though was long a familiar phrase in American culture.

The American Dream # 1, 1961, was one of his first Pop-styled works, and had particular importance as Indiana's first painting to be sold to the Museum of Modern Art, thus helping to establish his major reputation. The second went to MOMA's president, the third to the Van Abbemuseum in Eindhoven, the Netherlands, and the fourth to the Hirshhorn Museum in Washington. The fifth was acquired by Toronto, and had additional resonance for its reworking of the *Demuth Figure 5* image. He painted several variants of the number 6, also a number with strong personal associations. Indiana's father was born in June (the sixth month) into a family of six. He worked for Phillips 66 and called to mind travel on Route 66.

He painted the seventh *Dream* for a retrospective in Nice in 2000, using the occasion of the seven-hundredth year of the Grimaldi lineage to celebrate three famous American actresses who knew Paris and Nice: Josephine Baker, Isadora Duncan and Grace Kelly. Their names and his were enclosed in the four circles of the diamond composition. *The Eighth American Dream*, 2000 (p. 98), is the only one still in the

artist's possession, and the largest of the series. The eighth month was that of his mother's death, and so contains references to August, Carmen and bittersweet memory.[19]

The following year he completed the ninth and final canvas of the group in almost as large a format. It not only concluded the series, but also allowed him to surround the nine circles with words of places he had worked over his lifetime (Coenties Slip, The Bowery, Penobscot Bay), words from earlier paintings (EAT, DIE, LOVE), and phrases marking contemporary events: "Remember November, 2000," the date of the controversial presidential election. These later paintings are more typical of Indiana's recent work in their shift from the largely primary colors of the early career to a much broader palette including pinks and lavenders and other mixed colors. He has also widened his range of designs from the time-tested simple presentation of a single number to much more complex and intricately worked-out color patterns.

Two related pieces were spurned by their patrons, and remained with the artist. *Monaco 7* (page 28) depicted a single 7 within a circle, a simpler variant of the *Seventh Dream*, but when offered to the monarchy in honor of the anniversary, the image of a number was not deemed to be art and was refused. The same year Indiana painted in a square format *2000*, in celebration of the millennium year. He offered to New York City a large metal sculpture of the number for placement in an appropriate plaza or park, but was again declined.

One commission that at first failed but was subsequently resolved positively came from the Maine's governor's office. The invitation was to create a painting celebrating the state, and as many might, Indiana initially conceived of a canvas devoted to the coast. The resulting painting, *The Islands*, 2002 (p. 101), was a diamond containing four circles dedicated to pairs of the major islands. Interior bars, recalling his design for *The Melville Triptych*, suggest piers, horizon, and voyaging. The color scheme of blue, green, and white suited the juncture of evergreens and water. It is a beautiful and imaginative work, but proved unacceptable. Representatives of interior and northern Maine, where potato, blueberry and timber harvesting dominated, objected to the coastal bias. Indiana kept his work. His second effort was a happy success. *The First State to Hail the Rising Sun* (p. 124) centers on a large number 1 within a circle containing radiating green and yellow rays. Indiana went to Augusta for the official unveiling.

FIVE

Wood constructions have been an artistic interest of Indiana's since his first days in New York, when he came across old fragments of wood and metal in the warehouses he and others were renting as studios. At the Star of Hope he has kept a few examples of the herms he assembled in the early sixties, columns with painted bands and words,

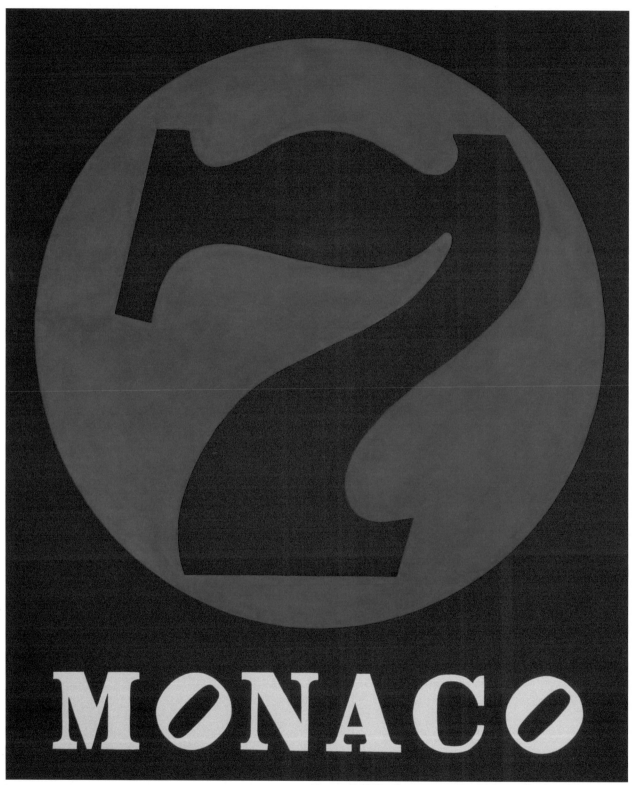

Monaco 7, 1997, oil on canvas; 60 x 50 ins.; collection of the artist

attached wheels, and before long, inserted pegs or dowels indicating the male phallus. At least one was hermaphroditic with phallus and breasts. Often the wheels were attached at the sides to suggest limbs. Some indulged in wordplay; for example, HOLE appeared below an actual hole in the wood beam, BAR beneath three painted bars, TWO beneath a pair of 2s, MOON with four painted circles and eight wheels, STAR above four painted stars, and so on.[20]

When he returned to such assemblages after several years on Vinalhaven, he was more likely to make use of the rougher, battered forms of driftwood washing ashore in the area, and gave them local titles, as in *BAY*, 1981 (p. 94). In a few cases he had pieces cast in bronze, then painted to match the original wood in a teasing play of media trompe l'oeil. These witty constructions take their place in the creative legacy of inventive forms and uses of materials that dates back to Picasso and Braque's synthetic cubist collages and Marcel Duchamp's inventive displacements and rearrangements of found objects early in the twentieth century.

In a burst of energy during the late 1990s and early 2000s Indiana produced a dozen or so wood constructions from pieces of old logs and worn posts, perhaps old telephone poles or broken masts from ships. Several were small and sexually charged, a few dramatically tall, like *EROS*, 1997, over twelve feet high, and *ZEUS*, more than twenty feet high, begun the next year. This last he called "a sea present," a waterlogged beam now with a weathered surface of silvery gray he was able to transform into a new identity of the supreme male god, standing like a sentinel or totem. Marching up one side are some dozen phallic pegs flanked by pairs of harrowing machine wheels with their sharp knife points. The result is a figure of aggressive grandeur, merging the American folk art tradition with ancient classical symbolism. To Indiana the gods were angered and challenged by the events of 9/11, and in a state of near despair in the days following he repainted the last two red letters of the title that appears a quarter of the way up the post, from ZEUS to ZERO. There are a few other instances in Indiana's art when a work undergoes a morphosis of identity over time, but few as personally meaningful and historically charged as this.

One painting, which underwent a similar transformation of identity due to unexpected circumstances, involved one of his most famous subjects—Marilyn Monroe. Originally, he has said, he hesitated to take on the image, given the notoriety it had acquired in the sixties in the hands of Andy Warhol. But his interest was partially triggered when he came across a small calendar pin-up photograph actually printed in Indiana. He couldn't resist making it the centerpiece of a singular diamond-shaped canvas of 1967, *The Metamorphosis of Norma Jean Mortenson*, whose first identity change was into Marilyn Monroe. Her birth and death dates, along with a play of letters added

and subtracted from one name to the other, are part of an elaborate visual narrative about her career.[21] The composition is equally complex in its formal orchestration of circles within the major circle, an allusion to the dial telephone she was holding at the time of her death, but also surely to the fortunes and misfortunes of the roulette wheel. Both its design and importance match *Mother and Father* (pp. 22–23), being painted at the same time. The Marilyn painting went to the McNay Art Museum in San Antonio.

Also in 1967 he painted an alternative version, which he titled *The Black Marilyn*. In contrast to the first with its bright color scheme, as the title indicates, this figure was surrounded by more lurid lavenders set against a black ground with its associations of mortality. Over three decades later he returned to the canvas for further reworking, and during the next few years began a new *Marilyn* series, focusing less on the individual biography and more on the general theme of the American love goddess. In one of these she appears as a mermaid, in another as *Ms. America*, in a third as a temptress of the Kennedys. Completing about a dozen variants, he sent them to Paris for an exhibition in the fall of 2001. He was in New York on September 11, ready to fly abroad for the show's opening, but was thwarted by the events of that day.

The Descent of a Love Goddess (Diamond) (p. 95), one of the Marilyn pictures, remains in the artist's hands, since transformed into a new identity. Hanging in a corner of his studio in the Star of Hope, over the course of a winter it was positioned on the wall where a leak in the roof occurred from ice and snow buildup. The water that ran down stained the left edge of the raw canvas, which being unprimed made it close to impossible to retouch without repainting the entire surface. Indiana let it be, and the more he thought about it, decided the offending stain provided a new meaning for his image. If the original love goddess was associated with President Kennedy, now she became reincarnated as Monica, that love goddess to President Clinton.[22]

Such pictorial wit is a constant current in Indiana's work, and surfaces intermittently within his more serious undertakings. Two other examples are equally entertaining. At the bottom of an all gray canvas he has painted in a darker gray the single word FOG (p. 97). "It is my one Maine landscape," he says. "One morning I woke up and looked out the window, and that's all I saw."[23] Its emptiness and floating letters remind us how much a precedent Indiana's visual ideas have been for the illusionism and minimalist aesthetic of younger artists like Ed Ruscha and Jenny Holtzer.

Another composition gives us the familiar arrangement of a circle enclosing an 8 on a vertical rectangle. The wording aligned around the circle reads: "Absolute Happiness/is Two Glazed Donuts Forever."

As we might expect, the text makes more than one reference. Often in the winter months the artist's assistants will bring out from Rockland on the morning ferry glazed donuts to have with coffee. This gesture in turn overlays the memory of Indiana's parents who had once run a donut shop. Of course, we can read the number as two donut holes, and we have already learned that 8 rhymes with ate, the passive of eat, his mother's last word.

We end where we began. Indiana himself over his long career has circled back in his later years to reprise his earliest subjects. The ginkgo tree, once such an overwhelming sensory presence in the artist's years on Coenties Slip, provided the imagery for *The Sweet Mystery* in 1962, and in 2000 was the basis for a new version. Meanwhile, a ginkgo tree was brought from New York and planted outside the Star of Hope, an aromatic reminder of the past in the present. The painting's legend can serve as a chapter title for the artist's last three decades— "Go from Coenties Slip/Thence to Vinalhaven."

Indiana has recently completed other gingko leaf paintings, several with the Chinese character Ping, the word for peace, thus mingling two favorite ideas together. A different echo has occurred with a redoing of the old Ellsworth Kelly *Easel* in a new painting on a much larger scale (p. 102). Now its wooden frame takes on the suggestion of architecture, perhaps subliminally the lines and patterns of the Brooklyn Bridge, so familiar a sight from the lower Manhattan waterfront. Elsewhere, he has been exploring the increased size of his designs, especially in monumental sculpture and its possibilities for public spaces. No doubt with both form and content in mind, he has declared, "the larger *LOVE* gets, the more attention it will receive."[24]

As we have learned, politics has often been on Indiana's mind and in his art. His 1962 painting *Yield Brother* employed the peace sign as a tribute to Bertrand Russell and the protest movement of the sixties. With the declaration of wars in Iraq and Afghanistan by the George W. Bush administration, Indiana was prodded into executing nearly two dozen canvases reusing the peace sign, surrounded with various cries of despair and anxiety. A different canvas recently devoted explicitly to Afghanistan (p. 96) revives his format of the *Confederacy* series of 1965. In place of the four southern states treated earlier, the map of Afghanistan occupies the interior of two surrounding circles containing the statement, "Just as in the Anatomy of Man Every Planet Must Have its Hind Part." Kabul is marked at the center, the symbolic site of the country's violence and conflict and geographic home to the Taliban.

Indiana's career has long been a mix of assertions, restatements and fresh declarations, just as his graphic ingenuity has pushed designs to the limits of their possibilities before attempting a new formulation. The most recent topical example of this is *HOPE*, a square of letters in both paintings and sculpture stimulated by the presidential campaign in the summer of 2008. For the Democratic National Convention in Denver, Indiana was commissioned to do an appropriate piece for the entrance to the convention center. Inspired by Barack Obama's message and recent book, *The Audacity of Hope*, he conceived of a six-by-six-foot stainless steel block of HOPE in the form of his *LOVE*, with the same O tilted in the upper right corner.

A long time friend Michael McKenzie, owner of the American Image Atelier and publisher of several Indiana prints, was instrumental in the commission, which was actually fabricated in Maine, to the artist's delight.[25] Optimistically, he once proclaimed, "My goal is that LOVE should cover the world. ... LOVE wins out in the end. ... LOVE is still the most important thing." Now with HOPE he could assert, "It's really a brother to LOVE, or a sister or a very close family member."[26] Where the earlier word was the claim and call of the so-called love generation, this new noun might inspire the hope generation. He has painted a dramatic version in black and white, with all its connotations of life and death and racial differences, as well as variants in celebratory red, white, and blue.

Robert Indiana is constantly navigating between pessimism and optimism, though hope has brought him and his art to the present moment. He can be at once feisty and philosophical. This is a richly productive career, not yet over, full of America's ambivalences and questions. His highly individual art has been powerfully influential, yet paradoxically little imitated. He deserves tribute above all for at least two significant accomplishments, the first being his pioneering recognition and appreciation for the early American avant-garde in literature and painting. His attention to those artists and writers came well before the general revival of interest by art historians and literary critics in later years. The second related achievement has been his distinctive fusion of images and words with utter clarity and verve in the tumultuous currents of modern American art.

NOTES

1 Susan Elizabeth Ryan: *Robert Indiana: Figures of Speech* (New Haven: Yale University Press, 2000).

2 Michael Plante: "Truth, Friendship, and Love: Sexuality and Tradition in Robert Indiana's Hartley Elegies," in Patricia McDonnell: *Dictated by Life: Marsden Hartley's German Paintings and Robert Indiana's Hartley Elegies* (Minneapolis: Frederick R. Weisman Art Museum, University of Minnesota, 1995), 57–87.

3 Conversation with the artist, September 11, 2007.

4 Conversation with the artist, June 13, 2008.

5 Susan Ryan discusses the Sanasardo picture more fully in *Figures of Speech*, 37–38. For illustrations and full discussion of Hartley's *Fishermen's Last Supper*, see Elizabeth Mankin Kornhauser, et al., *Marsden Hartley* (Hartford: Wadsworth Atheneum Museum of Art, 2003), 248–249, 321–314.

6 First published in John McCoubrey, *Robert Indiana* (Philadelphia: Institute of Contemporary Art, University of Pennsylvania, 1968); quoted in Ryan, 260.

7 These are reproduced in Joachim Pissarro, et al., *Robert Indiana* (New York: 2006), 26–28, 143.

8 See Pissarro, 18–22, 32.

9 Pissarro, 13–15, 24–25, 34–35.

10 Pissarro, 144–151.

11 Over the decades since its return to the artist, its pieces have suffered from neglect stored in his garage at Vinalhaven. Most of the light bulbs have disintegrated or been playfully replaced at times by empty cat tins. The entire ensemble has been re-electrified and restored for the Farnsworth exhibition.

12 Conversation with the artist, September 11, 2007.

13 Conversation with the artist, September 11, 2007.

14 Statement by the artist, *A Visit to the Star of Hope: Conversations with Robert Indiana*, a film by Dale Shierholt, Acadia Marketing in collaboration with the Farnsworth Art Museum, 2009.

15 Conversation with the artist, June 13, 2008.

16 See especially Susan Elizabeth Ryan: "Robert Indiana and Marsden Hartley: The Hartley Elegies," in *Robert Indiana: The Hartley Elegies: The Collection Project* (Lewiston: Bates College Museum of Art, 2005), 11–12.

17 For color illustrations and thorough discussion of the entire series of paintings by both artists, see *Dictated by Life*, and regarding the print version, *The Collection Project*.

18 See Liz Kelton Sheehan: "Decoding the Elegies," in *The Collection Project*, 45.

19 Statement by the artist, Shierholt film, 2008.

20 For these and other examples, see Pissarro, 13–46.

21 See the artist's statement quoted in Ryan, *Figures of Speech*, 267.

22 Conversation with the artist, June 30, 2007.

23 Conversation with the artist, June 30, 2007.

24 Statement by the artist, Shierholt film, 2008.

25 *Worcester Telegram Gazette*, August 30, 2008; and conversation with the artist, September 5, 2008.

26 Statements by the artist, Shierholt film, 2008; and *Worcester Telegram Gazette*, August 30, 2008.

THE STAR OF HOPE

by Michael K. Komanecky

Interim Director and Chief Curator, Farnsworth Art Museum

Star of Hope Lodge front doors, photo by author, 2008

The Star of Hope embodies all the elements of serendipity, dedication, intellectual rigor, artistic integrity, and opportunity Robert Indiana has long used to advance his beliefs through the subjects of his art, and which have so strongly shaped both his life and work. Serendipity, because it was the result of a chance visit to the island of Vinalhaven in 1969 on an invitation from prominent *Life* magazine photographer Eliot Elisofon that Indiana first encountered the former lodge of the International Order of Odd Fellows. Serendipity, too, that Elisofon's response to the artist's appreciation for the building was to buy it and then rent its upper floors to him to use as a studio. In 1977, four years after Elisofon's death, Indiana bought it from the photographer's estate for $10,000.[1] Dedication, because ever since Indiana began to spend the fall months there in 1970 and especially after he moved there permanently in 1978, he has not only marshaled his financial resources to preserve the weather beaten, once abandoned building but also devoted his formidable creative energies to construct a remarkable, ever-changing artistic environment within its already distinctive interiors.

In its very name, the Star of Hope also suggests the chance connections between its history and that of its most famous occupant. The star was one of the symbols of the Odd Fellows fraternal organization that once occupied the building. Prominently visible on the former lodge's front doors (left), the three stars referred not only to the name the Vinalhaven chapter chose for itself, but also to the Fellowship's three ideals—Friendship, Love and Truth. For Indiana, the star was one of several simple geometric forms whose interplay he repeatedly employed within the compositional and iconographic structure of his work. Stars naturally filled the field of his *New Glory Banner* (p. 20), an inventive reinterpretation of the American flag, while they took

on a very different meaning in *Hic Jacet*, where they were associated with America's military involvement in Vietnam. Stars function still differently as both symbols and unifying compositional components of numerous works in the 1960s including signature examples from the *American Dream* and *Decade: Autoportraits* series, and one of his many *LOVE* paintings .[2] There is also the unusual use of the word "star" in Indiana's 1961–62 painting, *God Is A Lily of the Valley*, in which Indiana includes the phrases, "God is a lily of the valley. He can do everything but fail. He is a tiger. He is a star. He is a ruby. He is a king." Indiana even incorporated the star into a stencil to mark crates used to transport his paintings (p. 36), an idea borrowed from the stencils he found in his Coenties Slip studio.

And hope, one of the virtues preached by the Odd Fellows and what they sought to offer the beneficiaries of their good works, has taken on new meaning in Indiana's art with his creation in 2008 of his *HOPE* sculpture commissioned by American Image Atelier for the National Democratic Convention in Denver as well as its many progeny in support of Barack Obama's campaign for the presidency (p. 105). A variant on Indiana's own iconic *LOVE* sculpture, *HOPE* has staked its own claim for a place in American culture, an example of Indiana's constant simultaneous exploration of autobiography and universal values as sources for artistic inspiration. As was the case for *LOVE*, Indiana has produced other examples of *HOPE* in different media and sizes.[3]

The connections between the words star and hope were, of course, coincidental, yet Indiana has characteristically searched for correspondences between these otherwise separate entities to challenge himself to create new work based in various ways on the foundations

INDIANA/VINALHAVEN packing crate stamp; photo by author

Thomas Wildey, Father of the I.O.O.F., color lithograph; collection of Robert Indiana

of what came before. Over the forty years during which he has made the Star of Hope his home and studio, the building has undergone repeated transformations, a metaphor for his own repeated reinventions of himself. What follows is an exploration of the Star of Hope's own history, before and after the artist's arrival on Vinalhaven, and how Robert Indiana has created one of the most singular artistic environments of our time.

THE INTERNATIONAL ORDER OF ODD FELLOWS
To visit the sick, relieve the distressed, bury the dead, and educate the orphan

These are the guiding principles of the Odd Fellows, an international membership organization that traces its history to medieval England, when in some small villages where there were not a sufficient number of craftsman to create a specific guild, workers in different trades, "odd fellows," joined together to create a local Guild of Fellows. During the reign of Henry VIII, the guilds, seen by the king as supporters of the pope, had their property confiscated. Henry's daughter and successor Elizabeth I suppressed the guilds further and in doing so diminished their ability to provide social and financial support to their members. The Free Masons and Odd Fellows managed to survive by providing these very services, primarily in London, but in their lodges elsewhere in England. The earliest surviving rules of the Odd Fellows date to 1730, from a lodge in London. Political and religious strife during the seventeenth and eighteenth centuries, however, caused repeated divisions within the fellowship and efforts by various factions of the Odd Fellows to reunite were only partially successful.

The first American branches of the Odd Fellows were founded at the very beginning of the nineteenth century. Washington Lodge No. 1 was founded in Baltimore as early as 1802, the Shakespeare Lodge No. 1 in New York began in 1806, and lodges were founded in Boston in 1820, in Philadelphia in 1821, and Washington, DC, in 1827.[4] These fledgling efforts were not always fruitful and, as one of its members wrote in an 1858 manual on the fellowship, "the only successful institution of Odd-Fellowship in this country—the fountain of our present organization—dates no further back than 1819. Thomas Wildey (left), a blacksmith by trade, an Englishman by birth, an America citizen by adoption, and a resident of Baltimore, inserted in the papers a call for a meeting of Odd-Fellows at the Seven Stars tavern, Second street, Baltimore."[5] Wildey (1782–1861), orphaned at five and later raised by an uncle, joined the Odd Fellows in 1804. He came to America in 1817 and two years later advertised in a Baltimore newspaper in search of other members of the fellowship. He and four others who responded to the ad met in the Seven Stars, thus founding what is considered the first chapter of the Odd Fellows in America.

The society grew quickly. By the 1850s the fellowship had expanded to include lodges in not only what were the original thirteen colonies and its adjacent territories—Maine, New Hampshire, Vermont, Massachusetts, Rhode Island, Connecticut, New York, New Jersey, Pennsylvania, Maryland, Virginia, North Carolina, South Carolina, Georgia, Alabama and Mississippi—but also in lands representing the nation's westward expansion—Louisiana, Ohio, Kentucky, Tennessee, Indiana, Illinois, Missouri, Arkansas, Iowa, and the formerly "foreign land" of Texas.[6] The membership in Pennsylvania and Ohio far exceeded that in other states; by 1860 there were some 44,000 contributing members in Pennsylvania and 21,000 in Ohio, the state with the next largest membership.[7]

This growth, however, was neither continuous nor without controversy. As the Odd Fellows themselves admitted, their organization was affected in the early 1830s by "the anti-masonic excitement, which arose in Western New York two years previously (and) spread rapidly abroad over the land. In several of the Northern States it took such general possession of the public feelings as to affect very materially the prosperity of our Order also, by the general prejudice excited against all so-termed 'secret societies.' In Massachusetts, the Order entirely died away."[8]

These sentiments were vigorously expressed in Maine, notably by the Congregationalist minister Stephen Thurston in a sermon he delivered on April 8, 1847, at the Methodist Church at Searsport and which he subsequently published as a pamphlet. Thurston methodically made his case against the Odd Fellows, challenging among other things its "arrogant and false claim to antiquity." He claimed, moreover, he could not give his "adhesion to an institution because it is a secret one … Men in the Lodge-room are shielded from the public eye, and removed from the restraints of public opinion."[9]

This secrecy, he stated, had further implications in that it led to:

> "a great gulf between a man and his wife. … He may not, on peril
> of the displeasure of the fraternity and the highest penalty of
> the Order, so much as whisper, in the privacy of the bed-room,
> and in the darkness of the night, even to the dearest friend, his
> bosom companion, his second self, one of the secrets of the
> institution."[10]

Criticism of the Odd Fellows' secretive behavior was not only a local phenomenon, however. In 1846, an anonymous "expelled member" published *Odd-Fellowship Exposed. Containing a full account of the work of the Order, As now practiced in the United States.* As its subtitle proclaimed, his intent was "An exposition of the signs, tokens, pass-words and grips belonging to the Independent Order of Odd Fellows, as practiced in the lodges of the United States; with the form of initiation

Title page illustration from ***Odd-Fellowship Exposed. Containing a full account of the work of the Order, As now practiced in the United States***, 1846. American Antiquarian Society, Worcester, Massachusetts

and explanation of the five degrees." Whatever pecuniary motivation may be ascribed to its author, he proclaimed a nobler purpose: "I have considered it duty to my God, my country and myself." The benefits of his confession were apparently soon evident. "As soon as I made up my mind to publish them, I felt at once at ease, and now feel like a new made man."[11] The author's revelations included what must be considered something of an exaggeration, if not parody, of the order's initiation rites, made visible for all to see on the pamphlet's only illustration, on its title page (above). The forlorn-looking author

stands in the center, a noose around his neck, surrounded by spear-carrying Odd Fellows in a composition strongly reminiscent of long-standing depictions of both Christ at the Column and Christ on the Cross, the latter where he is lanced by Roman soldiers. Other details in the illustration, such as the classical columns and the throne-like structure at the left, suggest the author's familiarity with some of the common decorations and symbols associated with the Odd Fellows. The prevalence of the skull on crossbones on the members' hats and robes as well as on the throne make clear the author's opinion of his companions' threatening intent.[12]

Reverend Thurston, however, was palpably earnest in his objections, which ran far deeper to the very nature of this and other similar fraternal organizations. One was what he viewed as its unseemly embrace of Christianity in the context of the strange ceremonies in which its members participated:

> "The mingling of religious services with some of the ceremonies of the Lodge room degrades religion. There are times and circumstances in which prayer, even, is out of place. It would be at the opening of a theatre, or a ball—over a gaming table, or at a carousal. To ask the blessing of God on such scenes and services would be a perversion of prayer—a mockery of serious things. So, it strikes me, would it be in the initiatory ceremonies of the Lodge. It would be such a mingling of the serious with the ridiculous, that the credit of religion would suffer by the process. With my present views, conscience would bitterly reproach me for offering prayer in such circumstances. We cannot take too much need to dissociate religion from the trifling and the ridiculous; otherwise many minds will come to regard religion with contempt."[13]

This intermingled practice of Christianity and Odd Fellowship was a grave matter to Thurston, who felt that "Odd Fellowship supplants the Church in the affections of those professing Christians who embrace it."[14] He decried "the testimony which professors of religion are made to give to the good character of corrupt members," and how the adoption by some lodges of the motto, "In God We Trust," was "a desecration of religious truth" in that despite the claims to the contrary, a good number of lodges' members "trample on the laws of morality."[15]

Another of Thurston's criticisms was the exclusive nature of the fellowship whose constituency, like others in the period, basically restricted its membership to white Protestant men. This criticism was apparently prevalent and in 1851 one of its members, Martin W. Homes, published a reply. An 1844 report by the organization's leadership stated "that no person is eligible to admission into the Order of Odd-Fellowship ... except free white males, of good moral character, who have arrived at the age of twenty-one years, and who believe in a Supreme Being, the Creator and Preserver of the Universe."[16] Homes pointed out that by the time of his publication, the fellowship adopted a different view, claiming that of "Infidels, Jews, Mohammedans, Idolaters, and Christians, none are excluded on account of their peculiar 'religious beliefs and practices,'" though the fellowship's membership nonetheless remained largely white and Christian.

In Homes' publication, in fact, he acknowledged that neither Indians nor "half breed's or males of mixed blood," even those "who are recognized by the laws of the land, as citizens and voters," would be allowed as members.[17] And, despite slavery's abolition, African-Americans continued to be denied membership, as was reported in an 1878 history of the Odd Fellows in Maine:

> "The following resolution was adopted for the purpose of settling a vexed question: Resolved, That admission to our Order, has always been restricted to the white race. That this law has been, and is now well established and understood wherever American Odd Fellowship is known, and that any and all attempts to change the same should not be countenanced by this R.W. Grand Lodge."[18]

As in so many aspects of post-Civil War American society, the end of slavery did not guarantee equal opportunity or equal rights for the nation's African-American population.

But it was neither religious nor racial restrictions to which Thurston objected most. He believed that Odd Fellowship was:

> "founded on wrong principles ... I am quite sure that they are unfriendly to the equal rights of the whole community. One of the advantages often claimed for the institution, is the help which it affords its members in matters of business. For instance, a shipmaster, who is a member, will find employment more readily than one who is not, whenever they have to deal with merchants who are members. A system of favoritism, without regard to merit, is adopted. So strong has this influence become, that some who have no partialities for the institution, have feared they should be obliged to join it in order to succeed in business."[19]

Such criticisms were widespread, it seems, threatening the very survival of the order during the late 1840s. A later chronicler of Maine's lodges wrote of "the dark days of 1845 to 1850, when the membership of the Order became greatly reduced and there was but little interest taken in it." The order's decline, he related, was due in part to the behavior of its own members:

"Some men, who then styled themselves Odd Fellows, consented to take part and share in the illegal distribution of lodge property, and divided the money that had sacredly been set apart for the relief of the widow and orphan, and appropriated some to their own personal uses."[20]

These circumstances notwithstanding, the attractions of membership —dedication to charitable activities, support for and from fellow members, indeed the economic benefits Thurston criticized, and, as we shall see, the exotic character of the organization's ceremonies and the regalia required to carry them out, as well as the commodious nature of the Odd Fellows lodges themselves—led to the organization's expansion all across the United States. The decades following the Civil War were a period of particular growth for the International Order of Odd Fellows. An 1878 history of the organization in Maine, for example, cited various cumulative national statistics from 1830 to 1874: some 925,000 initiations into the order, 685,000 members as well as 91,000 widowed families offered relief totaling more than $20 million from $55 million in revenue.[21] Statistics for the year 1874 alone revealed that there were forty-six Grand Lodges, nearly 6,000 Subordinate Lodges and more than 600 Rebekah Lodges (for wives of Odd Fellows). There had been more than 55,000 initiations into the Odd Fellows that year, bringing the total number of members to nearly 440,000, and the various members and lodges provided more than $1.5 million in relief from the $4.5 million in revenue.[22]

THE ODD FELLOWS ON VINALHAVEN

It was amidst this post-Civil War expansion of the Odd Fellows that the organization came to Vinalhaven. The I.O.O.F first made its appearance in the state at Maine Lodge No. 1, founded in Portland in 1843. Consistent with the growth of the organization nationally, there was relatively rapid expansion into towns and villages throughout the state in the 1840s, with lodges founded in its more populous and prosperous cities like Portland, Bangor and Belfast, as well as in its smaller villages and towns.[23] By 1846, there were more than thirty Grand Lodges in places such as Bath, Brunswick, Waldoboro, Eastport,[24] Lubec, Macchias, Calais and Cherryfield.[25] The mid-coast was no exception, with lodges in Thomaston, East Thomaston, and Camden by 1847.[26]

It was on November 23, 1874, that the Star of Hope Lodge No. 42 was initiated on the island of Vinalhaven. Its name may well have been a reference to the Seven Stars Tavern in Baltimore where the American branch of the fellowship was founded more than a half-century earlier. F.M. Laughton was its Grand Master, Joshua Davis the Grand Secretary, John A. Miller the Treasurer, and Martin H. Kiff, John Low, William H. Johnson, A.A. Beaton were its other charter members. Among its original thirteen members were also Henry S. Hopkins, John R. Merrithew, John F. Grant, Timothy H.

Arey, Joseph N. Ginn, C.A Creed, and Edward Jacobs.[27] By 1876 the new lodge was able to report a total of forty-five initiations, bringing its total number of members to seventy-three, having offered relief to four and burying two, and total relief amounting to just over $500.[28] Its appearance on "Vinal Haven," as it was known, was part of a statewide growth for the organization. At the Maine fellowship's annual meeting in 1874, a resolution was passed to appropriate $500 "or so much thereof as may be necessary … for defraying the expenses of reviving defunct Lodges, and instituting new ones, and that the Grand Master be authorized to employ such members of the Order as he may deem expedient for that purpose."[29] In addition, the state's Grand Master proposed that they commission a member to prepare a history of the order in Maine, with "an appropriation … made to amply recompense him for this time and labor while in the discharge of this very important duty."[30]

The Fellowship's arrival on Vinalhaven coincided with the island's growing prosperity. Originally named one of the Fox Islands (along with adjacent North Haven) by English sea captain Martin Pring in 1603, it was later renamed Vinal Haven, after the Boston attorney John Vinal, whose son William settled there and whom he assisted with other island residents to incorporate the town in 1789. By 1800, the combined population of the two islands was 1,860, and among its residents were fisherman, farmers, loggers and shipbuilders. Granite quarrying began in 1826, initiating nearly a century of quarrying, cutting and polishing stone for buildings throughout the country. Just prior to the Civil War, Vinalhaven granite was selected for large federal contracts to reinforce gun platforms along the Atlantic and Gulf coasts. Following the war, its granite was used to build U.S. customs houses in New York, Kansas City, and Buffalo; railroad stations in Chicago and Philadelphia; federal and other buildings in Washington; and for curbing and paving stones nationwide.[31] By the 1870s, the Bodwell Granite Company, formed in 1852 by Moses Webster of Pelham, New Hampshire, and George Bodwell, employed 1,500 workers on Vinalhaven.[32] By 1880, at the peak of granite quarrying on the island, more than 3,380 people lived on the island.[33]

When the Star of Hope lodge was formed in 1874, the island was also home to merchants and businesses suitable for its size and relative isolation. There was a grocer, butcher, stores for dry goods, notions, "millinery and fancy goods," and stoves and tinware, a tailor, restaurants and hotels. The island's industries included a horse net factory, one for making boots and shoes, a saw and grist mill, and an active lobstering operation, including canneries.[34] There was even a commercial photographer, Charles Vinal, a descendant of the family for whom the island was named.[35]

This bustling activity supported other fraternal organizations on Vinalhaven, all of which generally shared the Odd Fellows' charitable

ideals. In addition to the older and more prestigious Masons, the International Order of the Good Templars was already established when the Odd Fellows began.[36] The Templars organization was one of many founded in the mid-nineteenth century, based on Freemasonry and which focused its energies on temperance or total abstinence of alcohol. Founded in 1851 in Utica, New York, it grew rapidly and spread throughout the United States and, in the 1860s and 1870s, to Europe, Africa, India, Japan and South America. Unlike most of its counterparts, however, it admitted men and women equally and made no restriction of membership based on race.[37] By 1877, the Reform Club, another temperance society, was holding meetings in Vinalhaven.[38] Its members pledged, "for our own good and the good of the world, do hereby promise and engage, with the help of almighty God, to abstain from buying, selling or using alcoholic or malt beverages, wine and cider included."[39]

These attempts to control the use of alcohol were among many in Maine, going back to the formation in 1848 of the Temperance Watchman of Durham. In 1851 Maine became the nation's first "dry" state with the passage of the so-called Maine Law.[40] The temperance movement began to gain national prominence with the 1874 founding in Ohio of the Woman's Christian Temperance Union. The Odd Fellows, although its mission differed, was apparently also much concerned about the use and abuse of alcohol, at least in its lodges: in 1874 Maine's Odd Fellows adopted a resolution:

> "That all spirituous, vinous, and malt liquors shall be excluded from the Lodge rooms and ante-rooms, or halls connected with or adjoining thereto, when under control of any Subordinate or Degree Lodge or Encampment of this Order."[41]

Most of the fraternal organizations on Vinalhaven, however, had broader goals. In 1879 the Knights of Honor began weekly meetings on the island. Founded in 1873, they dedicated themselves to the care for the sick and to pay benefits to the heirs of deceased members.[42] In 1882 the Grand Army of the Republic held its first meeting. Founded in 1866 in Decatur, Illinois, by Benjamin F. Stephenson, its members were veterans of the Civil War, whose toll was felt as acutely in Vinalhaven as anywhere elsewhere in the nation. Maine had sent more soldiers per capita than any northern state: 73,000 Mainers served in the Union Army and Navy, more than 7,300 of whom died.[43] On Vinalhaven, more than ten percent of its residents served and twenty-three died; their service was memorialized by a granite Civil War Monument erected in 1870.[44]

The Odd Fellows first held their meetings in the hall over the Main Street shop of Martin H. Kiff, one of the lodge's charter members.[45] His store was in one of two adjacent buildings on the main street that

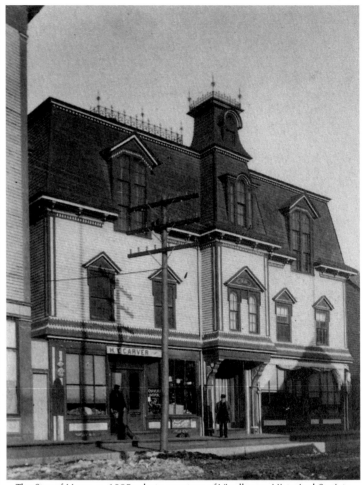

The Star of Hope, c. 1885; photo courtesy of Vinalhaven Historical Society

runs through the island's village and separates Carver's Harbor from Carver Pond. According to town records, the Odd Fellows acquired the properties in 1874. By 1884, they were flourishing. An article in the island's newspaper, *The Wind*, reported that "So great has been the increase of membership of late that they have been obliged to enlarge their hall, which is now neat and commodious.[46] The order, in fact, joined its two buildings, added a third floor, and adorned the new structure with a mansard roof and cast iron railings on the roof and above its central tower, imparting the whole with an up to date high Victorian splendor (above). Though most of the building served the needs of the Odd Fellows, its ground floor housed H.Y. Carver's Fruit and Confectionery Store, presumably providing a source of revenue to the lodge.

Even greater attention was given to the interior which, in order to carry out the Order's rituals, was richly decorated. The fellowship's inclination to expend considerable sums on outfitting its lodges was

well known and, in fact, was one of the criticisms cited by Stephen Thurston in his 1847 sermon on the evils of the Odd Fellows. He objected to the order, he said, "on account of its claims to be regarded as a benevolent institution." He decried:

"the heavy and useless expenditure of the institution. The fitting up of a Lodge room, its furniture, and dresses, and regalia, and gew-gaws, will cost, it is said, from several hundred dollars, to two thousand dollars; the larger part of which is totally useless as to any valuable purposes on earth."[47]

The Odd Fellows themselves, of course, felt differently. As Maine member Cyrus Kilby related in 1889, "If the members of our Order regard the lodge as their family, it is right and proper that they make the home as pleasant and attractive as possible."[48] He cautioned that each lodge "have a careful watch over the treasure and restrict the extravagant expenditure of money in the fittings and furnishings of lodge halls and paraphernalia."[49] He added further that:

"Gorgeously equipped halls, showy paraphernalia and high-sounding titles are not what constitutes true Odd Fellowship. Stripped of all these it is but a band of men who promise on their honor as men to be kind to each other under all circumstances, in adversity as well as in the brighter days of prosperity."[50]

Nonetheless, Kilby noted that:

"In most of the populous cities and large business centers where there are two or more lodges, there exists a laudable spirit of rivalry among the members to hold by ownership or rental large and beautifully furnished halls, where they can enjoy the weekly meeting, surrounded by comfort and costly art decorations."[51]

The purpose, he claimed, was simple:

"The attractions of the lodge-room often have much to do with creating an interest in the business and work of the lodge. Especially is this the case with persons who have never before been brought under the genial influences of social society. The mind of the initiate is diverted from business perplexities and domestic care, when surrounded by bright faces, pleasant smiles, and enticed by friendly words mingling in sweet accord with music and song in the beautiful home of pledge brothers."[52]

In the 1870s such goals were reflected in the design of many Odd Fellows lodges built throughout New England. As Kilby noted:

"[Boston's] Odd Fellows' Building … was erected in 1873, and stands among the most prominent public buildings in that city.

The main hall is fifty-four by ninety-four feet, and twenty-five feet in the clear. There are six lodge or working rooms, with encampment halls, Grand Lodge and Grand Encampment halls, Grand Secretary and Scribe's offices, committee rooms and banquet halls … Within the jurisdiction of the Grand Lodge of Massachusetts, here are more than two hundred lodges. Many of them occupy magnificent halls which are richly adorned. In order to conceive of their finely appointed halls and convey a correct idea of the picture, it is necessary that the reader look through his own eyes. A pen and ink sketch can furnish only a faint and imperfect outline of what would appear before him."[53]

The splendor Kilby saw in Boston was to be found in Maine as well, particularly in the 1880s when the Star of Hope was constructed. He described Rockland's Knox Lodge, for example, as "magnificent" and "ample and complete in every respect," while Camden's lodge as "an ornament to the Order and town. The hall is handsomely decorated and elegantly furnished."[54]

Plan of a Lodge Room of a Subordinate Lodge, I.O.O.F., 18__, American Antiquarian Society, Worcester, Massachusetts

By the time the Vinalhaven Odd Fellows built their new lodge, there appears to have been a prescribed pattern for the layout of its rooms (left). Though this plan from an 1875 Chicago Odd Fellows publication is for a "Lodge Room of a Subordinate Lodge," an entity somewhat lesser in size than that on Vinalhaven, it articulates how the organization's own hierarchical structure is imposed on the spaces its members inhabit for official purposes. The lodge's officers, for example, were assigned specific locations within the Lodge Room, and the plan suggests that these locations

were to be defined architecturally in some way. The entrance into the Lodge Room has been planned, too, with an "Ante or Preparation Room," which in this case also includes lockers in which the members would keep their ceremonial regalia.

The Star of Hope, however, was a full-fledged lodge and with its larger structure these various activities could be separated into distinct spaces. After entering at street level through a centrally located main door, lodge members proceeded through a small foyer to a wide stairway that led up to the next level to a card-room and living room, a ballroom, bathroom and kitchen. Members could go directly to these rooms without entering the stores located on either side of the main door. The room on the right at the first landing was the living room (Fig. 42A), which still contains built-in cabinets for storing the members' regalia, including costumes associated with specific ceremonies, a few of which have survived like the ceremonial hat pictured. (Fig. 42C).

Upstairs on the next level to the right is a narrow room which corresponds to the "Reception Room" on the 1878 plan (Fig. 42B). Richly adorned with stencil decorations on the walls and ceilings, it has what may be its original cast-iron stove. Through the door at the end of the vestibule is a smaller room (Fig. 44A) with large glass-fronted shelved cabinets that were probably used to house members' regalia and other objects used for ceremonial purposes. At the end of the room is the narrow double-door entrance into the large ceremonial chamber, outfitted with a peephole enabling those inside the chamber to identify those who sought entry. Even the door's hardware reflects the Odd Fellows' dedication to creating an environment entirely suited to their beliefs: its elegantly designed cast bronze door knocker and the escutcheon plate below both bear the three-link insignia of the Odd Fellows (Fig. 44B), symbolizing its three ideals of Friendship, Love, and Truth, emblems that were repeatedly used by the Fellowship in other kinds of decorations at the Star of Hope (Fig. 44C) and no doubt found at other lodges.

Once entry was granted, a lodge member entered the main lodge room, the largest and most elaborately decorated space in the building (Figs. 45A and 45B), reserved for the most elaborate of Odd Fellow ceremonies. The only known nineteenth-century photograph of the interior shows a corner of the room, revealing the stenciled decorations found throughout the lodge (Fig. 46). In addition, there were even more elaborate decorations, vignettes symbolizing the Fellowship's ideals located in a band across the uppermost portion of the room's walls. At the center on all four walls of the room are four throne-like chairs from which the lodge's highest officers presided over business as well as the Odd Fellows' lavish ceremonies. These thrones were an integral part of the Fellowship's lodges, deriving from the organizations'

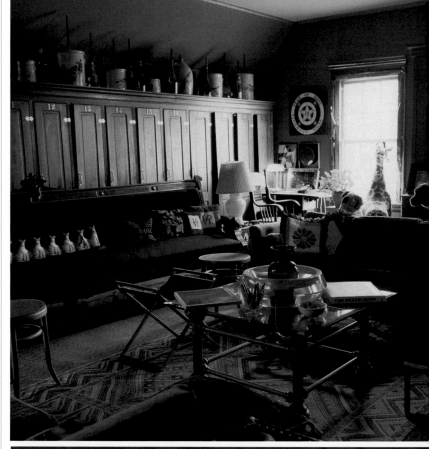

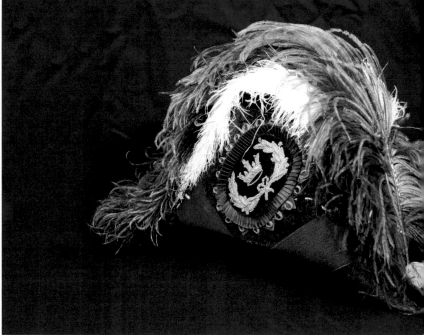

Clockwise from top left: Fig. 42A, Fig 42B, Fig. 42C

42

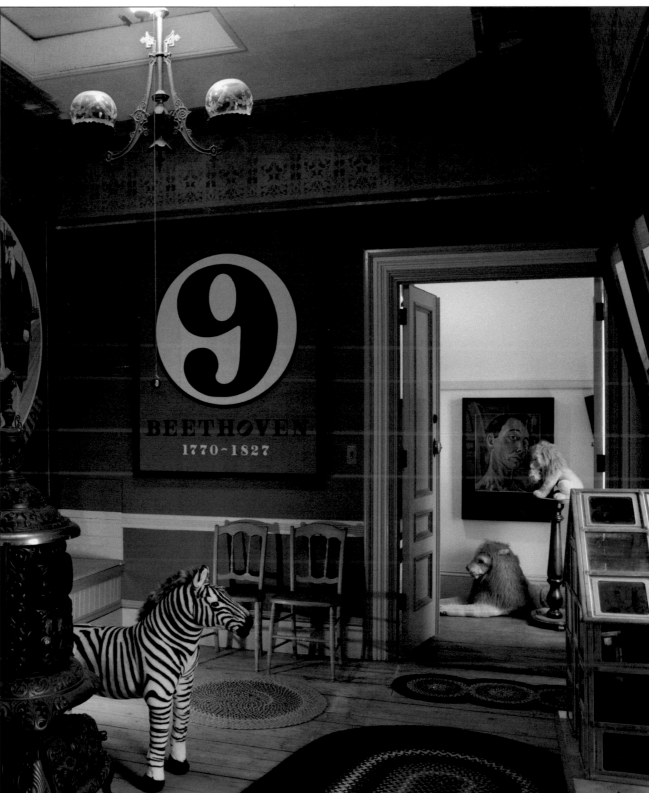

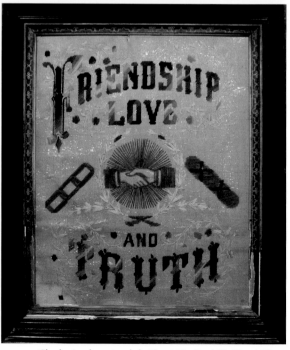

Clockwise from top left: Fig. 44A, Fig 44B, Fig. 44C

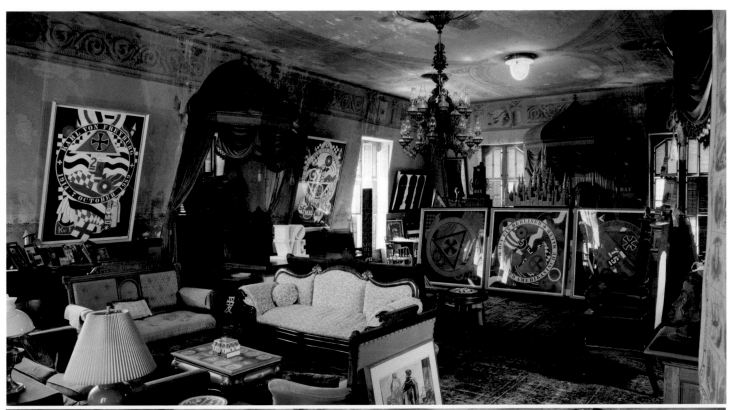

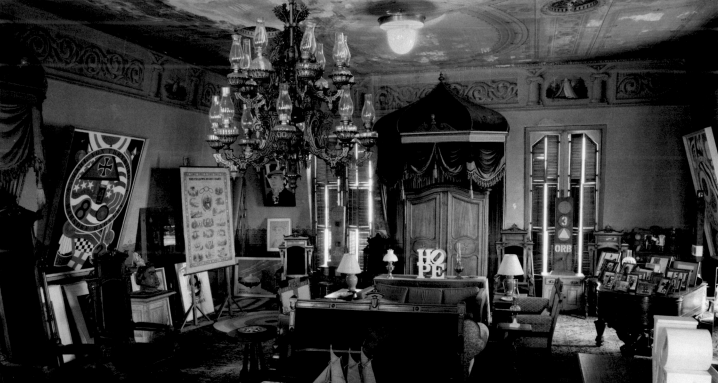

Top: Fig. 45A; bottom: Fig. 45B

45

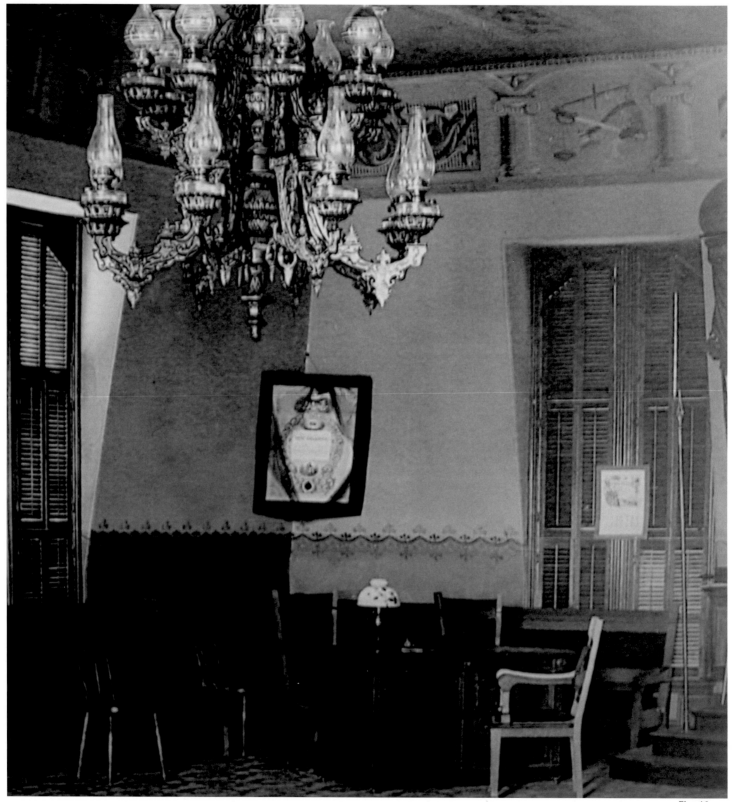

Fig. 46

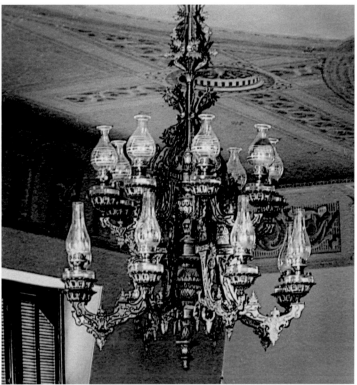

Clockwise from top left: Fig. 47A, Fig 47B, Fig. 47C

elaborate symbolism (Fig. 47A). With their large canopies they deliberately emulate a "Patriarch's Tent," which according to Odd Fellows literature was intended to remind members of the Israelites' journey to the promised land and, consequently, of the members' own journey through life. Furthermore, they considered these tents as "symbolical of peace, comfort, hospitality, the prominent characteristics of the shepherds of old," and hence behavior the Odd Fellows themselves sought to practice.[55]

Vinalhaven's Odd Fellows apparently enthusiastically endorsed the creation of such a sumptuous lodge; they calculated that they spent about $8,000 total for the building and its adornments.[56] These decorations included a large backdrop against which they carried out ceremonies (p. 63) and they even acquired china with the Odd Fellows initials emblazoned on each piece (Fig. 47C). One of the most visible of their acquisitions was the enormous bronze chandelier that hangs from the center of the lodge's main room, its size masked by the room's grand scale, captured in another historic photograph of the interior (Fig. 47B).

The Star of Hope Lodge enjoyed both growth and prosperity, and on November 27, 1894, it celebrated its twentieth anniversary "with interesting and appropriate exercises." Its prosperity was measured in statistical terms: its members now numbered 188, it took in receipts of $1,272.58, paid $632 in benefits, and had total assets of $9629.31. One of its charter members and its chief officer, A.A. Beaton, recalled proudly how the Lodge:

> "discharged its obligations to its members. No one was over
> looked. Impartial and generous treatment was accorded to all.
> Each strove to guard with jealous care the reputation and interests
> of each fellow member. The sick were visited, watchers were
> provided, when necessary. Benefits were promptly paid and
> when these were insufficient, charity was extended in each case.
> The dead were laid away tenderly and kindly ministrations
> given to the sorrowing ones. The orphans were cared for and
> all the details of its missions have been carefully looked after
> … Many an Odd Fellow's wife or widow in Vinalhaven has
> said with heartfelt sincerity: 'God bless Star of Hope Lodge
> and the Odd Fellows.'"[57]

These activities were surely important to the organizations' members on Vinalhaven. Illness and injury—the latter always a risk for the island's fishermen and quarry workers—could cause enormous hardship for the Odd Fellows and their families, and the Fellowship's social role was in many instances vital to its members.

In order to promulgate its ideals the Odd Fellows commissioned illustrated books and prints, many of which employed a carefully

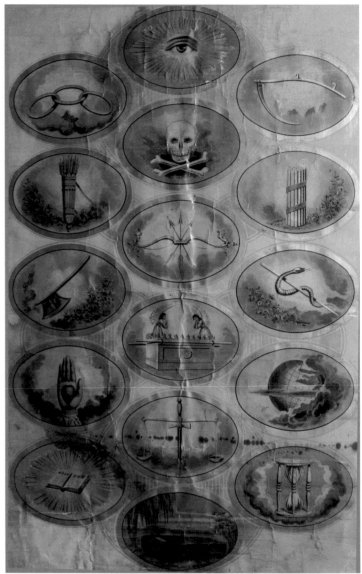

Hoen & Co., Baltimore, **Odd Fellows Symbols**, c. 1885, color lithograph; 36 x 23 inches; collection of Robert Indiana

constructed iconography. Their symbols were rich, as seen in a color lithograph produced by Hoen & Co. in Baltimore, the city where the American branch of the Odd Fellows was founded [above]. Its fifteen scenes (the same ones that decorate the walls in the Star of Hope's main chamber) are each displayed within an oval reminiscent of the oval links that signified the Fellowship's ideals; the links themselves can be seen at the upper left of the lithograph. The meaning of these symbols was explained in the Fellowship's publications. In the Hoen & Co. lithograph, they are divided vertically into three degrees—Friendship being the first, Love the second, and Truth the third, ideals of behavior central to Odd Fellowship. For example, according to the manual:

"The Eye enveloped in a blaze of light and glory, reminds us that the omniscience of God pierces into every secret of the heart … Let us, therefore, so regulate our conduct that we may not fear the scrutinizing eye of any one. The Three Links are emblematical of the chain by which we are bound together in Friendship, Love and Truth … The Skull and Cross-Bones remind us of mortality and warn us to conduct ourselves here on earth that heaven may be our reward hereafter … The Scythe reminds us that as the grass falls before the mower's scythe, so we, too, fall before the touch of Time."[58]

Symbols associated with "The First Degree or the Degree of Friendship" include a bow and arrows, reminders of:

"David and Jonathan and the covenant made between them. The Bow also recalls us to God's special provenance and promise to Noah, that the earth shall never again suffer from a flood. The Arrows direct that we shall pursue our daily tasks and perform our bounden obligations in the straight, direct path of duty. The Quiver teaches us that there should be a place for everything and everything in its place … Our quiver of usefulness should ever be full, [while] The Bundle of Sticks inculcates the importance of concentrated effort, as expressed in the axiom, 'In Union there is strength.'"[59]

In "The Second Degree or The Degree of Love," the axe stands for:

"the hardy pioneer … we are pioneers in the pathway of life, smoothing the rough places and removing all obstacles to the weak and the faltering. The Heart and Hand teach us that whatsoever the hand finds to do, the heart should go forth in unison…The work entrusted to us to perform should be one of love."

The globe was a symbol of the Fellowship's ambition to serve people throughout the world. Others emblems were distinctly biblical, for example the ark, called the "receptacle of the two tables of stone (containing the Ten Commandments) … which describes man's duties to God as well as his neighbor," while the serpent recalled "the brazen serpent erected by Moses to heal the stricken Israelites." The third and final "Degree of Truth" had its symbols as well. The scales and sword were commonly understood to represent justice and mercy, ideals to which the Odd Fellows were dedicated. Similarly, the Bible represented the source of the Fellowship's moral code. The hour glass and coffin were additional and otherwise common, long-standing symbols of mortality.[60]

Though it contains some of the same symbols as the Hoen & Co. print, an 1884 lithograph designed and published by T.C. Fielding of

T.C. Fielding, Boston, Massachusetts, ***Rock of Odd Fellowship***, 1884, lithograph; 25 1/2 x 19 1/2 inches; collection of Robert Indiana

Boston (above), employs much more complex iconography. At the very top of *The Rock of Odd Fellowship*, just below the eye, is the Hebrew word for "truth." The use of Hebrew suggested the members' erudition as well as the Fellowship's antiquity. In addition, it not only repeats one of the Fellowship's ideals but also refers to the all-seeing eye of God under whose watchfulness the members carried out their ministrations to those in need. Just below is the printed inscription, Victory of the Links, referring, of course, to Friendship, Love and Truth. An image of the links hovering over an open bible reiterates the Christian foundations of the Fellowship's ideals: "The Bible is the storehouse from which we draw instructions, and our guide to morality."[61] Directly below, two angels crown James L. Ridgely, Grand Secretary of the International Order of Odd Fellows in America, from April 24, 1840, until his death in 1881, whose portrait sits in a circle at the center of a five-pointed star—the very star that appears on the front door of Vinalhaven's Star of Hope Lodge.

M. Muldoon & Co., Louisville, Kentucky, designers; A. Hoen & Co.,
Baltimore, printer, **Ridgely Monument**, 1885, color lithograph;
19 3/8 x 15 3/4 inches; published by The Sovereign Grand Lodge,
I.O.O.F., Baltimore; collection of Robert Indiana

Completing this display of the Odd Fellows' lineage is a portrait
medallion of Thomas Wildey, credited with founding the Fellowship in
America. Commemorating Ridgely's role took on particular importance
in the 1880s; in 1885, just four years after Ridgely's death, the Sovereign
Lodge of the Odd Fellows of the United States laid the cornerstone of
a monument to him on "a high plateau in the west section of Harlem
Park" in Baltimore" where "the Sovereign Grand Sire, the Hon. Henry
F. Garey, laid the stone in 'Friendship, Love, and Truth.'"[62] The
monument itself became a subject of Odd Fellow imagery (above).

The iconography of *The Rock of Odd Fellowship* follows closely the
examples laid out in Fellowship literature. The pillar on which
Ridgely's portrait rests is one of three who together symbolize Faith,
Hope, and Charity, virtues whose origin can be found in classical
antiquity and which were subsequently embraced by Christianity.[63]
Appearing at the top of the Corinthian capital of the left-hand pillar
is a scene with an elaborately dressed elder before an altar with the

so-called Patriarch's tent in the background. The altar is "The Altar of
Sacrifice [which] reminds us that our selfish purposes and ungenerous
impulses must be restrained and sacrificed on the altar of Friendship,
Love and Truth."[64] Above the right-hand pillar is a depiction of the
Sacrifice of Isaac by Abraham, shown looking upward to God and
called upon to cease just before the fatal blow could be struck,
emphasizing further the Christian basis of the Odd Fellows' ideal and
their devotion to God.

Between the pillars are various scenes either drawn from well-established
Odd Fellows iconography or which elaborate in narrative fashion
the behavior expected of the Fellowship's members. There are also
contemporary scenes of caring for the sick, teaching children, helping
the misfortunate and burying the dead. Interspersed among these are
some of the more formal emblems of the Fellowship, including the
ark, "the receptacle of the two tables of stone containing the Decalogue,
which describes man's duties to God as well as his neighbor." The ark
had further meaning, however, for:

> "as the preservation of the Ark was an unceasing object of care
> to the Israelites, we are reminded by this Emblem to be solicitous
> for the preservation of our laws, and to ever hold them in such
> remembrance and respect, that our conduct in the world may
> bring no reproach upon the brotherhood."[65]

At the very bottom of the print, seemingly carved into the solid
"Rock of the Fellowship" are still more scenes instructive of the
behavior expected of each Fellowship member. At the very left, below
the pillar of Faith, three men kneel before the Tetragram, the Hebrew
letters signifying the unpronounceable name of God. To their right, a
stream rushes from the rocks, possibly referring to Moses' miracle of
finding water for the Israelites, though the Odd Fellows' literature
also describes the bible as a fountain from which "flows … a healing
stream, in whose waters are soothed and mitigated every affliction
and every cause of sorrow." The water motif is seen again at the far
right, where a soldier takes the hand of a pilgrim and leads him up a
steep pathway that leads to a well where a woman gives a drink of
water to another, both acts of charity under whose pillar these scenes
take place.

Such symbolism was not limited to the Odd Fellows, of course, as
similar imagery was used by the Masons, an older and somewhat
more prestigious fraternal benevolent association likewise intended to
nurture sound moral and social virtues among its members. The all-seeing
eye, ark, bible, columns, coffin, globe, pot of incense, serpent and
five-pointed star, in fact, were all used by the Masons.[66] The Odd
Fellows' combination of Old Testament scenes and their own arcane
iconography, surrounded by other trappings of classical antiquity such
as the columns and Corinthian capitals, were carefully constructed to

promulgate the Fellowship's ideals and to encourage an impression of the organization's ancient and noble roots. These devices were apparently successful, as Odd Fellow membership swelled in the decades following the Civil War and for the rest of the nineteenth century.

ROBERT INDIANA AND THE STAR OF HOPE

The grand age of fraternal organizations continued into the early twentieth century. The International Order of the Odd Fellows, like virtually all of its counterparts, however, gradually began to lose popularity in the decades following World War II. Despite the organization's decline, the Star of Hope Lodge remained active and the building itself remained in the hands of the fellowship. Its prominence today, of course, is due almost entirely to the fame of its most recent occupant, Robert Indiana.

His discovery of the Star of Hope and his move to Vinalhaven has been recounted many times in the extensive literature on the artist and his career, yet not always accurately. In 1969, Indiana was invited by *Life* magazine photographer Eliot Elisofon to come to Vinalhaven; Elisofon first came to the island where he had a summer cottage in 1940. Taking the ferry from Rockland, they arrived at the terminal at Carver's Harbor. Just beyond the terminal, the road to the left eventually leads to Elisofon's cottage, while the road to the right heads toward Main Street and into the island's namesake village where, on the left side of the street in the heart of the village, the Star of Hope stands.

When he first saw the then abandoned former Odd Fellows lodge, Indiana was struck by its faded Victorian splendor. Throughout the country, from this small island in Penobscot Bay to the Haight district in San Francisco, more and more Americans, particularly the young, were becoming enamored with the country's disappearing late nineteenth-century architectural heritage. The lodge's distinctive character struck a responsive chord in Indiana, who admitted "that from age seven on I was very, very much caught up with architecture. And at one time I really wanted to be an architect."[67] There was something else that may have played a part in the artist's instant affection for the Star of Hope. As Indiana admitted in a 1978 interview, he was also an "out and out romantic, hopelessly sentimental and nostalgic."[68]

The Star of Hope and its picturesque seaside location in a small village may have appealed to Indiana, too, as the kind of his place that might have satisfied his mother's seemingly endless searching for a better place to live, a journey that led to Indiana and his mother moving twenty-one times by the time he was seventeen. In some respects, the Star of Hope was the kind of house he himself had always dreamed of.

Beginning in 1970 he rented the place from Elisofon, using it each September as a home and studio. In 1977, four years after Elisofon's death, Indiana bought the building. At the time, Indiana had a five-floor, nine-room studio in a brick building in the Bowery, filled to the brim with his paintings, sculptures, prints, drawings, notebooks, and a comprehensive and carefully assembled archive not just of his work but virtually his entire life. The building's owner had terminated Indiana's lease in 1975, and Indiana had stayed as long as he could. Indiana's move to Vinalhaven required two vans making twelve trips, the last segment of which was the seventy-five minute ride on the small ferry from Rockland to the terminal at Carver's Harbor on Vinalhaven.[69] As he later said, it was a "horrendous move."[70]

When Indiana acquired the Star of Hope, the island's population was about 1,200, a decline of nearly two-thirds from its peak around 1900.[71] The demise of the granite industry in the late 1910s and the increasingly globally competitive fishing industry had diminished its prosperity, and the island gradually became more dependent economically upon its wealthy summer residents and visitors. Artists had only relatively rarely come there, at least in comparison with those who sought out the better-known islands of Mt. Desert in the nineteenth century and Monhegan in the twentieth. But it had had a few prominent artist visitors and residents. As Indiana later discovered, Marsden Hartley spent a summer there in 1938, and John Marin painted there regularly between 1914 and his death in 1953. In the 1950s and 1960s, Raphael Soyer spent summers painting and drawing on the island, and it was Soyer who recounted some of his interactions with another artist on Vinalhaven, printmaker and painter Mauricio Lasansky.[72] A few younger artists made their way there then, including painter André Racz, the head of Columbia University's art department, whom Indiana got to know.

It was Indiana's arrival, however, that altered the artistic universe on the island, particularly as he became increasingly occupied with renovating the Star of Hope. Soon after moving to Vinalhaven year-round, Indiana began a concentrated campaign to restore the building, which by that time was nearly completely denuded of its paint and whose clapboards and other wooden decorative details were in danger of disappearing altogether (top p. 52). In 1981, Indiana nominated the house for placement on the National Register of Historic Places. The application noted that the structure was the last surviving example of the ornate Victorian buildings which once existed on Main Street (center p. 52), and that its ornate lodge hall on the top floor of the building was still intact. The equally splendid Opera House next door, which had once held the meeting rooms of the GAR, had just been demolished to make way for a single-story and functional but architecturally bereft U.S. post office. National Register status enabled Indiana to take advantage of certain tax advantages, and for the next three years scaffolding surrounded the house as its wooden exterior was refurbished and painted (bottom left). The work was completed just about the time of the centenary of the Odd Fellows' own 1884 refurbishment of the building.

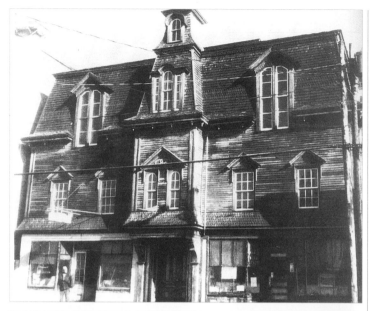

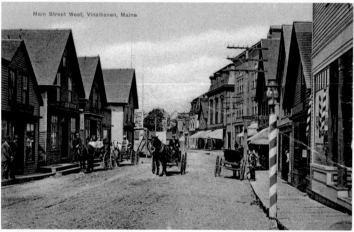

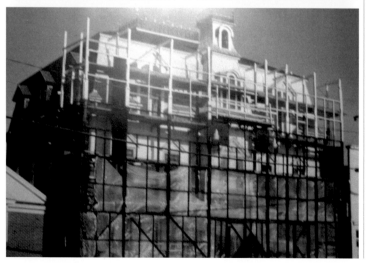

The project coincided with the Farnsworth Museum of Art's 1982 exhibition, *Indiana's Indianas*, which featured the works that the artist retained in the Star of Hope. The show revealed his calculated plan to preserve his own legacy. "The Farnsworth show will be practically my entire collection of my own work ... I set a policy early on to keep a major work from each year."[73] As he described it, the show also provided Indiana with an opportunity "to establish the fact that I'm here in Maine."[74] His concerns were not necessarily unjustified, as his 1978 departure from New York took him away from the place where he had enjoyed so much recognition so quickly in the 1960s. Unlike his friends and contemporaries—most were neighbors at his Coenties Slip or Bowery studios, including Ellsworth Kelly, Robert Rauschenberg, Jasper Johns, Roy Lichtenstein and Andy Warhol—and, despite his critical and commercial success, Indiana had not been given a one-person show at any of New York's major museums. His move to Vinalhaven, as it turned out, has probably made it all the more difficult to remedy what seems a surprising oversight given Indiana's international reputation.

It did, however, provide him with other kinds of unexpected opportunities. In 1985 Pat Nick formed Vinalhaven Press, which was quickly recognized as one of the most significant fine art printmaking operations in the country. Indiana was in the group of seven artists who worked at the press during its opening year and he did prints there in 1986, 1990, 1991 and 1992 before the press closed in 1996.[75] His first was *Mother of Exiles*, a 1986 etching and aquatint depicting a bare-breasted and anguished figure of Liberty from the renowned Staten Island statue (top right). Ever the watchful critic of American politics and culture, when the print was done Indiana simply stated, "I think Liberty has a great deal to cry for," reflecting a life-long liberal's distaste for the conservative turn in American politics during the Reagan administration.[76]

But *The Mother of Exiles* also offers, perhaps inadvertently, Indiana's view of his move to Vinalhaven, for he himself was in self-imposed exile. As he said in an interview published just before his 1982 exhibition at the Farnsworth, "So far I've just been hiding out, but I'm really not a recluse."[77] He contributed to his own isolation, however, claiming in a 1988 interview that "I never answer the telephone. I'm a fairly private person. Here, people pretty much respect each other's privacy."[78] In that respect, Vinalhaven and the Star of Hope gave him just what he wanted and, by implication, what he could no longer have had in New York. The city was "a constant drain—demanding ... let's judge a show—give a talk—just endless."[79]

In the same interview, Indiana revealed an important aspect of why life at the Star of Hope was so appealing. Talking about the subjects that engaged him, he mentioned humanism and its limited visibility

Above: Star of Hope, c. 1970; collection of Robert Indiana; center: Main Street, Vinalhaven, c. 1900; postcard, courtesy of Vinalhaven Historical Society; bottom: Star of Hope under restoration, c. 1982; collection of Robert Indiana

during his own lifetime, noting that "My painting is very much concerned with some of these problems." He noted further, however, that:

"My art is really detached—form, color, celebration … I'm standing away from personal aspects of life. It's what puts me on Vinalhaven, twelve miles from the mainland—hundreds of miles from everybody in New York."[80]

Amidst this isolation, Indiana nonetheless began to discover unexpected connections with the island, first through its by then defunct granite industry. One of Indiana's first jobs upon coming to New York was working in the office of Dean James A. Pike at the Cathedral of St. John the Divine.[81] It was the Bodwell Company of Vinalhaven, in fact, that was commissioned to provide eight immense granite columns for the Cathedral, begun in 1899 and completed three years later, in two sections weighing 90 and 40 tons (bottom right).

By far the most significant artistic consequence of his move to Vinalhaven, however, was his inadvertent discovery of the art of Marsden Hartley. Hartley, one of America's most accomplished modernist painters, was born in Lewiston, Maine, and after pursuing his career in New York, Berlin, and New Mexico in the 1910s and 1920s, he returned to his native state. In 1938, the sixty-year old artist spent a summer on Vinalhaven. His show at Alfred Stieglitz's An American Place gallery in New York the previous spring was largely unsuccessful, and Hartley's critical and financial positions were declining. Emotionally, he was still mourning the tragic 1936 drowning of two young brothers, Donny and Alty Mason, who died in a boating accident in Penobscot Bay. Hartley's sorrow may well have been intensified from having had a sexual relationship with Alty.[82]

Hartley's arrival on Vinalhaven seemed to lift his spirits, even if only temporarily. "It is a most beautiful place, so quaint and really picturesque, something at every hand to paint … so that is my next location … I am sort of cheering up to think I might get a place of my own, and really get settled."[83] He was only on the island for that summer, though, and soon moved further down east to more remote Corea, painting there in a chicken coop. He died four years later, alone, in Ellsworth. Hartley's reputation fell further after his death, and he was largely ignored until the first major retrospective of his work at the Whitney Museum of Art in 1980—just two years after Indiana's move to Vinalhaven.

Hartley's brief stay on Vinalhaven took on momentous importance for Indiana, who learned that Hartley spent that summer of 1938 in a building across the street from the Star of Hope. Admittedly working "very much by the magic of coincidence,"[84] Indiana began to study Hartley's work, centering on a series of paintings he did in 1914–15 in memory of his fallen friend and presumed lover, Karl von Freyburg, killed shortly after beginning his service in the German

Mother of Exiles, 1986, hard ground etching and aquatint, 36 x 24 ins.; Farnsworth Art Museum, museum purchase, 1988

Preparing granite column for Cathedral of Saint John the Divine, Vinalhaven, c. 1890; photo courtesy of Vinalhaven Historical Society

army during World War I.[85] Inspired by these works, Indiana embarked on his own commemorative series of eighteen paintings and then ten silkscreen prints made between 1989 and 1994. Done in rectangular, diamond and tondo format, they took as a point of departure Hartley's so-called War Motif series. They are simultaneously an homage to one of the foremost American modernist painters, and a visual poem on the two artists' shared interests in radical formal vocabularies, their innovative combinations of letters and numbers into their imagery, as well as their lives as homosexual artists and their experience of living and working in Maine.[86]

Although the evolution and meaning of these works by Indiana have been carefully examined elsewhere, it is important to recognize the meaning Indiana himself attributes to the geographical coincidence that led him to embark on these works:

> "The most compelling thing in my being here on the island is my involvement with Hartley ... Hartley is mostly an artist identified with Maine. He was a native of Lewiston. Hartley couldn't tear himself away. He would go away and come back. He had a love-hate relationship with Maine. This is removed from my own experience. He was a poet. I've been a poet as well as a painter. He's had a great impact on my life. Seventy—sixty years ago, he was doing paintings I had been doing for most of my life—words, letters and numbers. In 1938 Marsden Hartley came here for the summer. The kids threw rocks at him. He was pretty scary looking ... Hartley suffered the same fate as Louise Nevelson—you could hardly find a Hartley in Maine. Mostly, he's pretty much ignored."[87]

Added to these threads that connected Indiana's life with Hartley's was the former Odd Fellows lodge to which Indiana moved. Its location, of course, inadvertently led to Indiana's discovery of Hartley and the younger artist chose to acknowledge that connection in two of Indiana's *Hartley Elegies* paintings, and in the prints of those paintings, *KvF V* and *KvF X* (pp. 110, 115). Inscribed in a circle in both paintings, accompanying Hartley's and von Freyburg's names, are the words Truth, Friendship and Love, a variation on the motto of the International Order of Odd Fellows. It has been suggested that Indiana's use of the motto is a tacit recognition of the homosocial character of the Odd Fellows organization and its emphasis on men's dependence on one another, a serendipitous but meaningful connection between Hartley, Indiana, and the latter's relatively new-found home. As Indiana biographer Susan Ryan has noted:

> "The Vinalhaven Odd Fellows hall thus provided Indiana with the perfect setting in which to frame his *Elegies*. Interestingly, the culture of fraternal societies such as the Odd Fellows was steeped in both ritual and coded identification symbols ... There was an aptness, then, in Indiana's adaptation of the

language of Odd Fellowship, with its fraternal affection, to characterize the Hartley-von Freyburg relationship. Just as the Odd Fellows had relied on a system of codes to recognize each other, so did pre-Stonewall gay men depend on a system of shared signs for mutual identification, and for the purposes of developing a community."[88]

Further, Indiana's transposition of the words of the motto, from Friendship-Love-Truth for the Odd Fellows to Truth-Friendship-Love in his *Elegies* paintings, has been read as Indiana's "insistence on the truth, upon rewriting history to reflect positively the emotional and possibly sexual relationship that the two men (Hartley and von Freyburg) had and that was veiled for so long."[89] Indiana's identification with Hartley's homosexuality may be reflected in a comment he made in another interview in which he explained his interest in the earlier artist: "I was simply moved by Hartley's tragic life ... It seemed that he was simply plagued with misfortune. Just as my exile to Maine has been a misfortune."[90] Indiana's "misfortune" can be interpreted as the consequences of his removal from the critical attention of the New York art world, and of a more personal set of circumstances. Although he rarely speaks about it, Indiana has experienced his own share of difficulties on Vinalhaven, due in part to some islanders' intolerance of his sexuality. Like Hartley, Indiana was not always welcome in his new home.

Indiana's connectedness to Maine has manifested itself in his art in other ways as well. His 1993 painting, *FOG* (p. 97), is a tongue-in-cheek reference to a constant aspect of life along Penobscot Bay, summer or winter. The plain, unmodulated pale grey surface of the painting is but a symbol, identified for the viewer by the painting's title inscribed across the bottom of the canvas. Incorporating a motif first used in *LOVE*, the word's O has been tilted to energize the simple three-letter word. By 2002, Indiana's tenure on Vinalhaven and his prominence as an artist led to a commission from the state of Maine for a painting to adorn the State House in Augusta. Indiana's response was a diamond-shaped painting entitled *The Islands* (p. 101) whose form and colors refer to the world that Indiana came to know best from his time in Maine, eight of its estimated 3,000 islands. Paired together in each of the circles are Mount Desert and Islesboro, Monhegan and Matinicus, Isle au Haut and Hurricane, and North Haven and Vinalhaven. The islands' names are inscribed in circles, islands themselves set against a deep blue field representing Maine's coastal waters. Unfortunately, Indiana's fondness for these islands was not viewed as sufficiently representative of the state as a whole, a state which obviously has a vast interior stretching to the Canadian border on two sides and much of which is distant from the coast. The painting was rejected, though soon replaced by another work, *The First State to Hail the Rising Sun* (p. 124), that better suited his patrons' wishes. Gradually, then, Maine became firmly implanted in the artist's subject matter.

THE STAR OF HOPE: HOME AND STUDIO

Indiana's work has long been seen as essentially autobiographical, a reading that he himself has encouraged. As he states in the film produced as part of this exhibition, "I am painting and writing my own history."[91] As Susan Ryan has observed, the autobiographical character of Indiana's work is central to understanding both the art and the artist. Many stories, as well as his works:

> "may not give us the inner core of the man, if we can speak of such a thing, but they demonstrate an artist-narrator who is as seamlessly and consistently structured as his work, and who projects, both in presence and in print, the same sense of being masked or behind a scrim that has been associated with his paintings. Indiana's autobiographical storytelling and his visual art are his parallel systems of creative production. In the latter, though, the terms have undergone bilevel coding into visual and verbal signifiers. That the works are more than fragments of stories or incomprehensible clusters of signs and symbols— that they are compelling compositions that seek to triumph over the limits of telling."[92]

It is from this perspective that the Star of Hope itself should be considered as one of this "artist-narrator's" most self-consciously personal statements. Home has always been a shifting, sometimes unsettled, sometimes idealized concept in Robert Indiana's fertile imagination. As he has recounted many times, due both to his father's changing jobs and even more to his mother's seemingly eternal search for a better place to live, Indiana moved repeatedly during his childhood and teenage years. He described his own moves as an adult *like that nightmare that I went through with my mother* [author's emphasis]."[93] How then, from this peripatetic existence and experience, does one define home? Seeking to define what a home is, it can be argued, has been a lifelong task for Indiana, consciously accepted and nourished. To cite just one example, in 1968, the then famous and successful forty-year old artist returned to Indianapolis and photographed as many of his former houses as he could find, even including the sites of homes that had been demolished or replaced. In his ever autobiographical method, he produced an album from his trip, "Twenty-One Houses," which he planned to turn into a book for which John Updike offered to write a text.[94]

As Indiana gained a foothold in the New York art world, home became equated with his studio, and studio with his home. He first took up residence in New York in 1954, after a summer at the University of London. He found his first studio the next year, on West 63rd Street, then moved to Book Row at 61 Fourth Avenue. In 1956 he moved to his third studio at 31 Coenties Slip, with a view of the East River and the Brooklyn Bridge. In 1957, when this building was razed for a parking lot, Indiana moved into a second loft at 25 Coenties Slip. There he remained until 1965 and it was there that he

made friendships with several of the artists who later moved to the Slip—Ellsworth Kelley, Jack Youngerman and his wife the actress Delphine Seyrig, Lenore Tawney, Agnes Martin, John Kloss, James Rosenquist, Charles Hinman, Ann Wilson, John Baldwin, and Alvin Dickstein; Cy Twombly also painted works for his last Stable Gallery show in Indiana's studio.[95]

The impact of the place on Indiana is well-known: number 25 was covered with signs painted on its brick façade (pp. 68, 69)] advertising the wares of a previous tenant ("Appliances," T.V. Radios," "Jewelery," and "Cameras"), and his discovery of brass stencils in the interior "became the matrices and materials for [his] work."[96] He later described Coenties Slip as "that most spectacular of creative enclaves in the history of New York … now lost to progress and ugly commercial expansion in what was once the original Dutch settlement on Manhattan."[97] In the mid-1960s, Coenties Slip was targeted for demolition and development, however, and Indiana was forced to find a new home. He found a large space at 2 Spring Street in the Bowery, "formerly a sweatshop luggage manufactory" where he was joined by Hinman and Will Insley, the latter born in Indianapolis and also represented by Stable Gallery. It was there that Indiana remained until his final move to Vinalhaven in 1978.

His studios at Coenties Slip and the Bowery featured significantly in his personal and artistic narrative—after all, he spent nine years at Coenties Slip and thirteen at the Bowery during the period in which he so firmly established his artistic reputation. Both of his studios were photographed and published, due not only to his rapid rise to prominence in the early 1960s but also his willingness to share his world with the public. As intensely private as Indiana may be, he has always been keenly aware of the need to promote himself and has carefully considered the ways in which he sought to do so. Entry into his home and studio was one of them.

For any artist, the studio typically serves several purposes, and for Indiana in particular his studios have been carefully constructed environments that function simultaneously as his residence, studio, archive, gallery and museum. Just about the time Indiana was considering his permanent move to Vinalhaven, he spoke about his studio on the Bowery. He had 3,000 square feet there on five floors. Originally a suitcase factory, its ground floor spaces were shops where the factory's goods were sold and which he converted so that "the ground floor is a kind of buffer to the upper floors." More important was the way in which he utilized the rest of the building.

> "I have a studio for each activity. I have a drawing studio; I have a graphic room; I have a sculpture studio and a painting studio; I have living quarters; I have storage; I have my private gallery. There's a room which serves as an office and library."[98]

This separation of activity, perfectly logical from one perspective, is intimately tied to Indiana's penchant for order and organization, a hallmark of his work. "Part of the reason for taking over a whole building was the hope that I could separate the activities so that they wouldn't be on top of each other." Although he confesses not to be able to live up to this ideal, he realizes that "it's very hard for me to start something when things are in disorder."[99]

And once settled into a space, Indiana seems to have been determined to ground himself in his environment:

> "I'm always shocked when so many New York painters move practically every two or three years … they're always looking for the better studio with a better light or more windows or a bigger skylight or an elevator or some small physical advantage which necessitates a move, which to me is totally disruptive and very unpleasant. … It doesn't seem that very many American artists' aspiration or dream is to make their studio the kind of situation that the European seems naturally to have done. I suppose that is part of the difference of being an American or being a European. I like to feel, myself, no particular European influence, but I can certainly relate to that European direction of establishing a very special place where all the special things are found."[100]

Speaking about his Bowery studio, he matter-of-factly stated, "Everything that ever happened to me—with few exceptions—is right here. … Over a period of time, things have accumulated, and I'm a keeper. I just don't discard things."[101] It is a habit the artist admits began as a young boy and has continued unabated. There's a purpose to his self-archiving:

> "I've never turned my things over to archives or anybody else. I feel that in a sense everything I have is still active. … When I do part with things, it's usually with great reluctance. And, in a sense, my art is really a reflection of that. There's no experience I've had that cannot be pulled upon, cannot be used, that I would refrain from using. And I enjoy that. It's part of the process of my work. And there's a very sentimental aspect to all this."[102]

Hence there was something deeper in concept of what a home and studio could and, it appears, were supposed to be.

What also must be considered is how Indiana's works take pride of place in his carefully constructed environment. Some are recently made and some are in progress, while there is also a large and diverse collection from throughout his career. As he himself noted, early on in his career he strove to keep critical examples. Hence despite the sale of his paintings, prints and sculpture over the years, he has without question the most comprehensive retrospective collection extant of

his work. It even includes drawings from his high school years, one obtained from his former high school art teacher who, when Indiana appeared unannounced at her door, pulled out a drawing she kept because of her conviction that he would some day be famous.[103] Another is a drawing from the same period that Indiana saw on e-Bay and quickly scooped up. In addition, there are paintings from his days as a student at the School of the Art Institute of Chicago, and he has examples of virtually every print he has ever made, and posters for nearly every show in which his work has appeared, including those he designed himself.

Not unexpectedly, there are several versions of his *LOVE* sculptures (pp. 78, 79, 80, 81, 103). In addition to the now sagging maquette for the first one, there are samples of commercial reproductions found in museum stores throughout the world, and variants produced by artist friends and assistants. Banks of cabinets hold his drawings, notebooks and diaries.[104] Ring binders contain photographs of most of his works, including those taken and sent to him by friends and acquaintances. Moreover, he has assembled a library of every book and publication in which his work has appeared. Virtually every letter sent to him finds its way into his archive as well.

The question can fairly be asked whether the Star of Hope is any different from his previous studios and, if so, how. As one critic noted about Indiana's Bowery studio just before he moved to Vinalhaven, it was "a place of personal myth supported by a thousand artifacts."[105] To be sure, Indiana's archival approach to preserving a collection of his own work reveals a side of his character that extends far beyond an artist's desire to keep a portion of his artistic legacy. Thus, in one respect the only difference among his studios is that Indiana has had another thirty plus years to accumulate the things that now fill the Star of Hope. A visitor there today cannot help but be overwhelmed with the countless, disparate pieces of his life that are there: books, records, awards, copies of the daily *New York Times* going back decades, clothes going back to his time in New York in the 1960s, not to mention the many gifts from friends and visitors, including the immense carpet in the former lodge's main chamber, given to him by his artist friend Louise Nevelson, who had grown up in Rockland, the mainland town from which the ferry to Vinalhaven departs.

What is new is the decidedly playful aspect of the world Indiana has created at the Star of Hope. Among the gifts visitors bestow upon him are stuffed animals of all kinds—giraffes, tigers, bears, dogs, birds, even a gorilla, who inhabit the building's many rooms. Few visitors escape without hearing a flock of small yellow ducks moving animatedly as they sing "Singing in the Rain,"[106] or a diminutive dog soulfully belting out "Love is Made for You and Me."[107] Repeated visits reveal how these animals' placement changes according to Indiana's whims. On one visit, a group of his large giraffes may greet a visitor coming up

the main stairwell, while on another they might be seated around a dining table in the former Odd Fellows second-floor card room, while on another they may surround one of his works in the nearby Sail Loft studio. They have even traveled to Zürich for one of his recent exhibitions. They have a life of their own, it seems, giving the Star of Hope its own animated personality.

Yet it is not just the amount of time Indiana has lived in his Vinalhaven home that makes it different from his previous places at Coenties Slip and the Bowery. There are ample suggestions that the Star of Hope has a deeper meaning for the artist. Even while still living in his studio at the Bowery, Indiana seems to have recognized the growing importance of his Vinalhaven retreat. Placed prominently in his Bowery dining room was Lowell Nesbitt's large painting of the façade of the Star of Hope, painted in shades of grey and giving it an especially austere if not haunting appearance. Above the painting, as if to crown his soon-to-be permanent home, Indiana placed a gilded wood version of the three oval links that symbolize the Odd Fellows' ideals of Friendship, Love and Truth, which he found in the former lodge.

Once settled in the Star of Hope and once he had the building stabilized, Indiana took advantage of what the building, its decorations, and surroundings offered him both in terms of artistic expression and the lifestyle it offered him. Indiana's interest in the detritus of the Odd Fellows that he discovered there, for example, can be seen simply as another example of his archival compulsions. But as everywhere else he lived as a professional artist, he quickly sought to put his personal stamp on the environment. Thus one of the few intact ceremonial Odd Fellows costumes that survived is, now at least, regularly worn by a life-sized skeleton whose red eyes flash when activated on and off while it sings "WHAT." On one visit, the author encountered the dressed skeleton in the card room on the second floor, and on another inside the small wooden building at the back of the house (a former town jail), turned by Indiana into a small rotating installation of his works and other objects.

Outside, residing somewhat perilously next to the wooden structure, is Indiana's tall 2000 wood and metal sculpture originally titled *Zeus* (right). Like so many things at the Star of Hope, even that sculpture underwent change during its time there. On September 11, 2001, Indiana was in New York, visiting his old home before departing that evening for Paris to attend the opening of a new show of his work there—a flight he never boarded, of course. Instead, Indiana witnessed and photographed the destruction of both towers from a rooftop location in lower Manhattan. Upon his return to Vinalhaven several days later, he embarked on a refashioning of the Star of Hope's façade, covering its ground floor, former storefront windows with large sheets of plywood and painting on them large images of the American flag (p. 58), and adorning the top of the building with a series of real

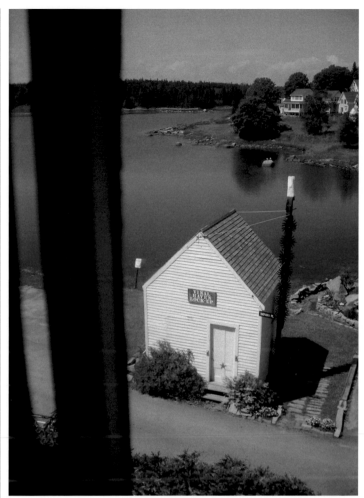

View from the Star of Hope of **Zeus/Zero**, 2000-2001, Wood, iron and oil on wood, 278 x 22 x 22 inches; collection of the artist; photo by the author, 2008

flags. For an artist whose works were often associated with the antiwar and counterculture sentiments of the 1960s, it was as public a patriotic response as made by any American artist in the immediately post-9/11 period. By virtue of the Star of Hope's prominent location facing Carver's Harbor, the flags could easily be seen by the Rockland-Vinalhaven ferry as well as fishing and pleasure boats entering the harbor.

Indiana's transformation of *Zeus* was more subtle. It was named, of course, for the ancient Greek god whose importance is suggested by the sculpture's immense height. As John Wilmerding has pointed out, Indiana transformed a waterlogged beam into a sentinel- or totem-like god, whose phallic wooden pegs and rusted steel harrowing machine wheels give it an aggressive grandeur, thus merging a folk art tradition with ancient classical symbolism. The events of 9/11, however, plunged Indiana into a state of despair, and led him to repaint the

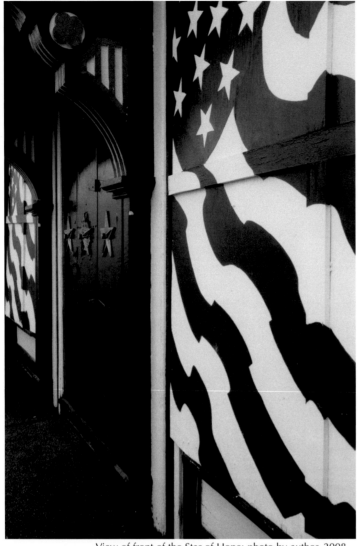

View of front of the Star of Hope; photo by author, 2008

stove (right). But virtually every work of art in the Star of Hope is subject to Indiana's unrelenting inclination to create new relationships between his works and, at the same time, altering the character of the interior world which they inhabit. With the removal of so many works for this exhibition, the inner spaces of the former Odd Fellows lodge will take on a fresh expressive character, finding a different equilibrium between things old and the new, large and small, painted and sculpted—all as if it were a stage set for the presentation of his acute sensibilities. This penchant, too, is reflected in the building's history, as the Odd Fellows themselves carried out some of their ritual ceremonies and other performances before a large painted backdrop that still survives (p. 63).

This ongoing visual drama at the artist's Vinalhaven home and studio is an essential part of what is surely one of the artist's most ambitious, imaginative, complex and continually evolving creations. In this simultaneously private and public space, Indiana is the actor, and the Star of Hope his stage. And just as our understanding of the nineteenth-century American painter Frederic Church is informed by visiting Olana, his Moorish-inspired estate picturesquely perched overlooking the Hudson Valley, so is our understanding of Robert Indiana immeasurably enriched by experiencing the ebb and flow of life at the former Odd Fellows lodge, the Star of Hope.

sculpture's last two red letters, turning *Zeus* into *Zero* and the piece's imposing height now referring to the fallen towers. Indiana has frequently revisited works throughout his career to create new ones, but in no other is the artist's transformation so deeply personal and historically charged as in *Zero*.

Transformations inside the Star of Hope take place regularly. Some works of art seem to have a more or less permanent home, like Nesbitt's painting of the building. It sits over the stairwell, visible descending the stairs on a wall parallel to the façade and thus mirroring what's outside. Similarly, Indiana's large sculpture, *Eros*, stays put on the stairs, its size and weight making frequent moves difficult. *Mother and Father* (pp. 22–23) reside on the second-floor reception room on the wall opposite the windows, arranged symmetrically around the cast-iron

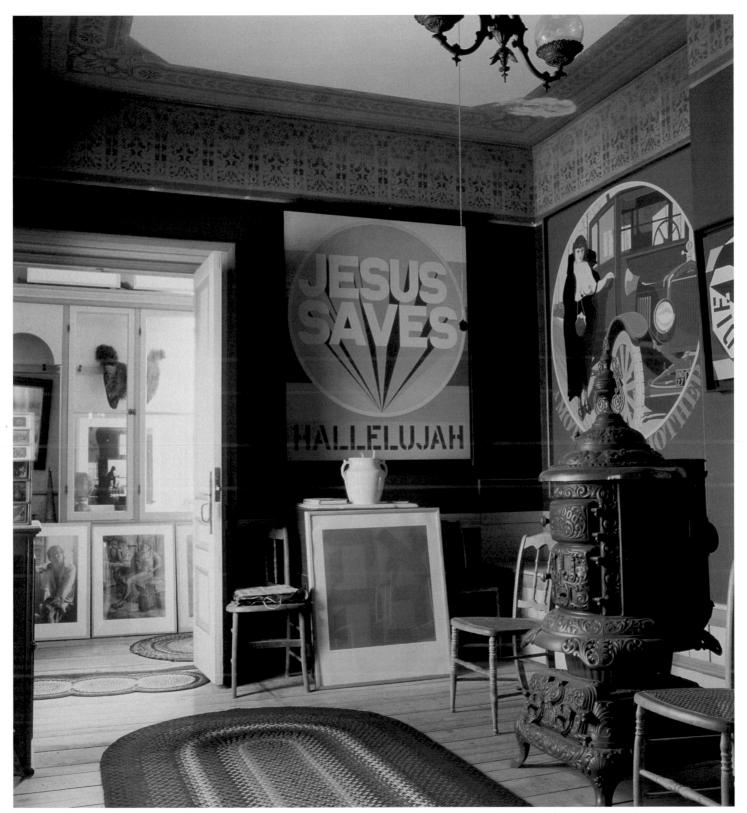

Robert Indiana; photo by author, 2008

NOTES

1 David Colman, "At Home with Robert Indiana," in *The New York Times, February 6, 2003.*

2 These include, among others, *Terra Haute* (1960), T*he American Dream No. 1* (196061), *Bardrock* (1961), *Four Star Love* (1961), *The Calumet* (1961), *The President (A Divorced Man Has Never Been President)* (1961), *The Triumph of Tira* (1961), *The Black Diamond American Dream No. 2* (1962), *The Demuth American Dream # 5* (1963), X5 (1963), *The Metamorphoses of Norma Jean Mortenson* (1967), and *Decade: Autoportraits: 1966* and *1965 (1972–77).*

3 At the time of this publication, there are both bronze and stainless steel versions of the sculpture, measuring 18 x 18 x 9 inches; and oil silkscreen on canvas renditions of HOPE in various color combinations, measuring 18 x 18 inches. These silkscreens are signed and numbered on the back by Indiana. In addition, T-shirts, lapel pins, and other HOPE-emblazoned items were sold on the website, BarackObama.com, proceeds from which were used to support the Democratic Party in the 2008 presidential election; it is estimated that more than $1.0 million dollars was raised from these sales.

4 Aaron B. Grosh, *The Odd-Fellows Manual* (1855): 27-28.

5 Grosh, 28.

6 Grosh, 38.

7 Grosh, 36.

8 Grosh, 37. The "anti-Masonic excitement" to which Grosh refers stems from an incident that took place in Batavia, New York, in 1826 when the Mason William Morgan disappeared after threatening to reveal various secrets of the organization; Masons in the area were subsequently accused of his murder, leading to a growing, national anti-Masonic movement. See Clement M. Silvestro, *Masonic Symbols in American Decorative Arts* (Lexington: Scottish Rite Masonic Museum of Our National Heritage, 1976), 12.

9 *Odd-Fellowship to be Avoided. A Sermon delivered by request, in The Methodist Church at Searsport, Fast Day, April 8, 1847. By Stephen Thurston. Pastor of the Congregational Church in Searsport.* (Portland: Printed by Thurston & Co., 1847), 10, 15, and 29. Copies of the rare pamphlet may be found in the American Antiquarian Society in Worcester, Massachusetts, and in the Maine State Historical Society Library in Portland, Maine.

10 Thurston, 20.

11 *Odd-Fellowship Exposed* was published in New York, "printed for the publisher, and for sale by the booksellers generally," including "for sale at all the News and Periodical Agents in the United States." A copy of the publication may be found in the American Antiquarian Society in Worcester, Massachusetts.

12 Eli Baxter's parody, *Odd Fellowship Exposed* (New York: Winchell & Small, 1872), took an equally critical view of the order. Its sinister title page illustration showed a standing coffin in which an

Odd Fellow faced the viewer wearing regalia that were frequently the subject of ridicule. A copy of this publication, originally priced at twenty-five cents, may also be found in the American Antiquarian Society.

13 Thurston, 24.

14 Thurston, 25.

15 Thurston, 25 and 26, respectively.

16 Martin W. Homes, *Odd-Fellowship: Its Merits and Demerits, being a History of its Origins with its Rise and Progress in England and the United States* (Utica: D. Bennett, 1851), 113–114. A copy of this publication can be found in the American Antiquarian Society.

17 Homes, 116.

18 Cummings, 245.

19 Thurston, 30.

20 Cyrus Hamlin Kilby, *Binding of the Links. A Story of Forty Years in Odd Fellowship* (Portland: Published by the author, 1889), 24.

21 *History of Odd Fellowship in Maine* (Portland: F.G. Rich & Co., Printers and Publishers, Corner Exchange and Fore Streets, 1878), 244.

22 *History of the Odd Fellowship in Maine*, 244.

23 Nathaniel G. Cummings, *History of Odd-Fellowship in Maine* (Portland: G.F. Rich & Co, 1878): 49.

24 T*he Odd Fellows' Almanac and U.S. Lodge Directory for the Year 1846* (Boston: United States Publishing Company, 1846), 48–49.

25 Kilby, 13.

26 *The Odd Fellow' Almanac*, 48–49; and *History of Odd Fellowship in Maine*, PAGE.

27 From "Odd Fellow Anniversary," a November 27, 1894, article from an unknown publication in the Vinalhaven Historical Society.

28 *History of Odd Fellowship in Maine*, 49-50.

29 *History of Odd Fellowship in Maine*, 230.

30 *History of Odd Fellowship in Maine*, 226.

31 Esther Jones Bissell, "Introduction," in *Images of America: Vinahhaven Island* (Vinalhaven: The Vinalhaven Historical Society, 1997), 9.

32 Bill Caldwell, *Islands of Maine: Where American Really Began* (Portland: Guy Gannett Publishing Co., 1981), 183.

33 Caldwell, 169.

34 Edmund S. Hoyt, *Maine State Year-Book, and Legislative Manual, for the year 1874–75* (Portland: Hoyt, Fogg & Donham, 1874). 334; and Caldwell, 169.

35 Hoyt, 334.

36 Hoyt, 334.

37 By 1875, however, the American branch of the I.O.O.G.T voted to allow separate lodges for white and black members, accommodating itself to the practice of segregation in southern states. See David M. Fahey, "How the Good Templars Began: Fraternal Temperance in New York State," *Social History of Alcohol Review*,

Nos. 38-39 (1999); and Fahey, *Temperance & Racism: John Bull, Johnny Reb, and the Good Templars* (Louisville: University Press of Kentucky, 1996).

38 Edmund S. Hoyt, *Maine State Year-Book, and Legislative Manual, for the year 1877–78* (Portland: Hoyt, Fogg & Donham, 1877), 377.

39 In the *Newsletter of the Androscoggin Historical Society*, No. 5 (February 1992).

40 See William David Barry and Nan Cumming, *Rum, Riot, and Reform: Maine and the History of American Drinking* (Portland: Maine Historical Society, 1998).

41 *History of Odd Fellowship in Maine*, 232.

42 Edmund S. Hoyt, *Maine State Year Book, and Legislative Manual, for the year 1878–79* (Portland: Hoyt, Fogg and Donham, 1879).

43 Amy Hassinger, *Finding Katahdin: An Exploration of Maine's Past* (Orono: The University of Maine Press, 2001), 173.

44 The monument is pictured in Bissell, 14; according to a caption accompanying a photograph in Bissell, 66, the GAR held its meetings in the back room of a building adjacent to the Star of Hope, the Grand Army of the Republic Memorial Hall.

45 *A Brief Historical Sketch of Vinalhaven* (Rockland: The Free Press, 1889). My thanks to Melanie Hardy Mahony at the Maine State Library for this reference.

46 A notice found in *The Wind*, Vol. 1, No. 1 (January 5, 1884).

47 Thurston, 11 and 14.

48 Kilby, 85.

49 Kilby, 86.

50 Kilby, 92.

51 Kilby, 86.

52 Kilby, 86.

53 Kilby, 91-92.

54 Kilby, 89.

55 Theodore A. Ross, O*dd Fellowship: Its History and Manual* (New York: The M.W. Hazen Co., 1895), in Chapter XI, "Emblems, Regalia, and Jewels," 579. From a copy in the collection of Robert Indiana.

56 *Brief Historical Sketch of Vinalhaven*.

57 From "Odd Fellow Anniversary."

58 Ross, 575.

59 Ross, 576.

60 Ross, 576–578.

61 Ross, 578.

62 "The James L. Ridgeley Monument," in the April 28, 1885 issue of *The New York Times*.

63 Ross, 578.

64 Ross, 579.

65 Ross, 577.

66 Silvestro, especially 47–52.

67 Robert L. Tobin, "Conversations with Robert Indiana," *Robert*

Indiana (Austin: University Art Museum, University of Texas, 1977): 26.

68 John Loring, "Architectural Digest Visits: Robert Indiana," *Architectural Digest*, Vol. 35, No. 9 (November 1978): 120.

69 Edgar Allen Beem, "A Painter of Signs: Robert Indiana," in *Maine Art now* (Gardiner, Maine: The Dog Ear Press, 1990), 65.

70 Beem, "A Painter of Signs," 65.

71 According to the 1980 census 1,211 people lived on the island.

72 Raphael Soyer, *Diary of an Artist: Raphael Soyer* (Washington: New Republic Books, 1977), 137.

73 Beem, 78.

74 Quoted in Edgar Allen Beem, "Robert Indiana: At Home in Penobscot Bay," *DownEast Magazine* (August 1982), 78.

75 Aprile Gallant, "Getting Graphic: Experimentation at the Vinalhaven Press," in Aprille Gallant and David P. Becker, *In Print: Contemporary Artists at the Vinalhaven Press* (Portland: Portland Museum of Art, 1997): 32.

76 Quoted in Gallant, 32.

77 Beem, "At Home in Penobscot Bay," 78.

78 Quoted in Lynn Ascrizzi, "Indiana," in *MaineSay* (June 1, 1988), 3.

79 Ascrizzi, 5.

80 Ascrizzi, 5.

81 See John Wilmerding, "Indiana and Maine: States of Play," [13].

82 Barbara Haskell, *Marsden Hartley* (New York: The Whitney Museum of American Art, 1980), 100.

83 Letter from Marsden Hartley to Isabel Lachaise, 18 October 1937, Yale Collection of American Literature, Beinecke Rare Book and Manuscript Library, Yale University. Quoted from Susan Elizabeth Ryan, "Robert Indiana and Marsden Hartley: The Hartley Elegies," in *Robert Indiana: The Hartley Elegies*. The Collection Project (Lewiston: Bates College Museum of Art, 1997), 10.

84 Beem, "A Painter of Signs," 64.

85 Indiana's relationship to Hartley is fully examined in Patricia McDonald, *Dictated by Life: Marsden Hartley's German Paintings and Robert Indiana's Hartley Elegies* (Minneapolis: Frederick R. Weisman Art Museum, 1995).

86 See Michael Plante, "Truth, Friendship, and Love: Sexuality and Tradition in Robert Indiana's Hartley Elegies," in *Dictated by Life*, 57–87.

87 Ascrizzi, 5

88 Plante, 85–86. "Pre-Stonewall" refers to the June 1969 riot that took place at Greenwich Village's Stonewall Inn, where gay patrons resisted police harassment. See Plante, 58.

89 Plante, 86.

90 Plante, 57.

91 *A Visit to the Star of Hope: Conversations with Robert Indiana*, a film by Dale Schierolt, Acadia Marketing in collaboration with the Farnsworth Art Museum, 2009.

92 Susan Elizabeth Ryan, *Robert Indiana: Figures of Speech* (New Haven and London: Yale University Press, 2000), 7.

93 Tobin, 31.

94 Ryan, 14 and note 8.

95 These and other biographical details are drawn from Indiana's own "Autochronology," published among other places in Tobin, 54–55. For a discussion of the Autochronology, see Ryan, 11–13.

96 Quoted in Hélène Depotte, "Towards an Immobile Voyage: Robert Indiana, the Reality-Dreamer," *Robert Indiana: Retrospective 1958–1998* (Nice: Musée d'Art Moderne, 1998), 36-37. A photograph of the front of number 25 can be found on page 17.

97 "Autochronology," 53.

98 Tobin, 29.

99 Tobin, 31.

100 Tobin, 31.

101 Loring, 113 and 120.

102 Tobin, 29 and 37.

103 Related several times in interviews with the artist in 2008.

104 See Daniel O'Leary, "The Journals of Robert Indiana," *Love and the American Dream* (Portland: Portland Museum of Art, 1999): 8–29.

105 Loring, 113.

106 Lyrics by Arthur Freed and music by Nacio Herb Brown, published in 1929.

107 Music and lyrics by Milt Gabler and Bert Kaempfert, recorded by Nat King Cole in 1964.

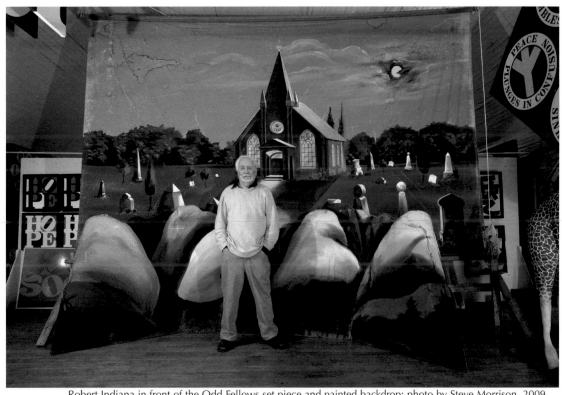

Robert Indiana in front of the Odd Fellows set piece and painted backdrop; photo by Steve Morrison, 2009

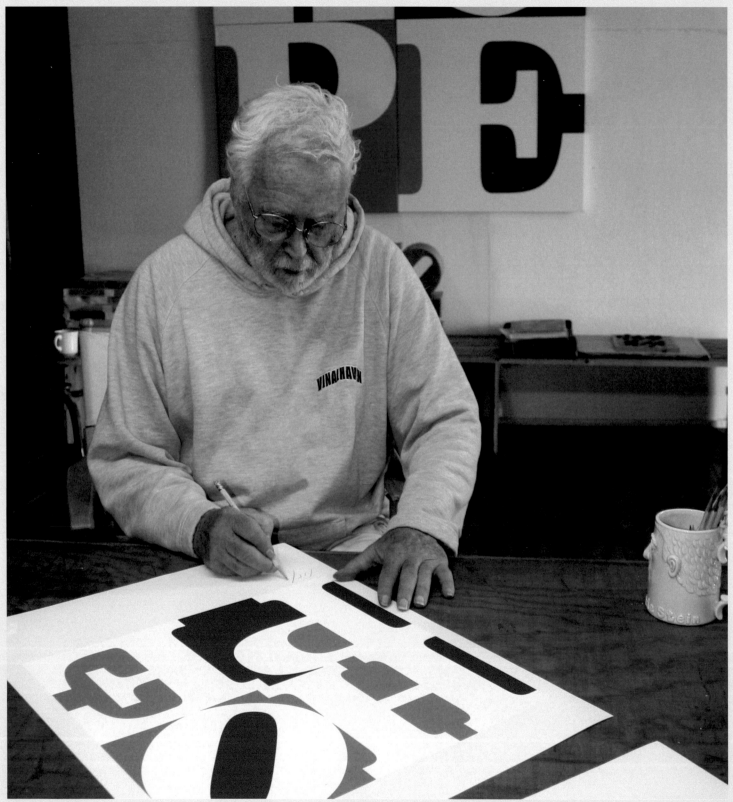

Robert Indiana signing *HOPE* print

ARTWORK

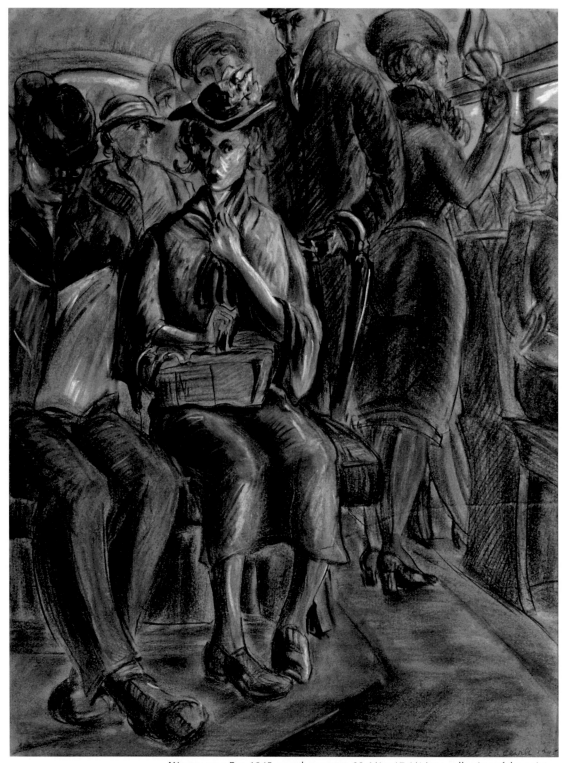

Woman on a Bus, 1945, pastel on paper; 23 1/4 x 17 1/4 ins.; collection of the artist

Untitled (railroad signal station, Indianapolis, a few blocks from Arsenal Tech High School), c. 1945–1946, pen, ink, and watercolor on paper; 19 1/4 x 23 1/2 ins.; collection of the artist

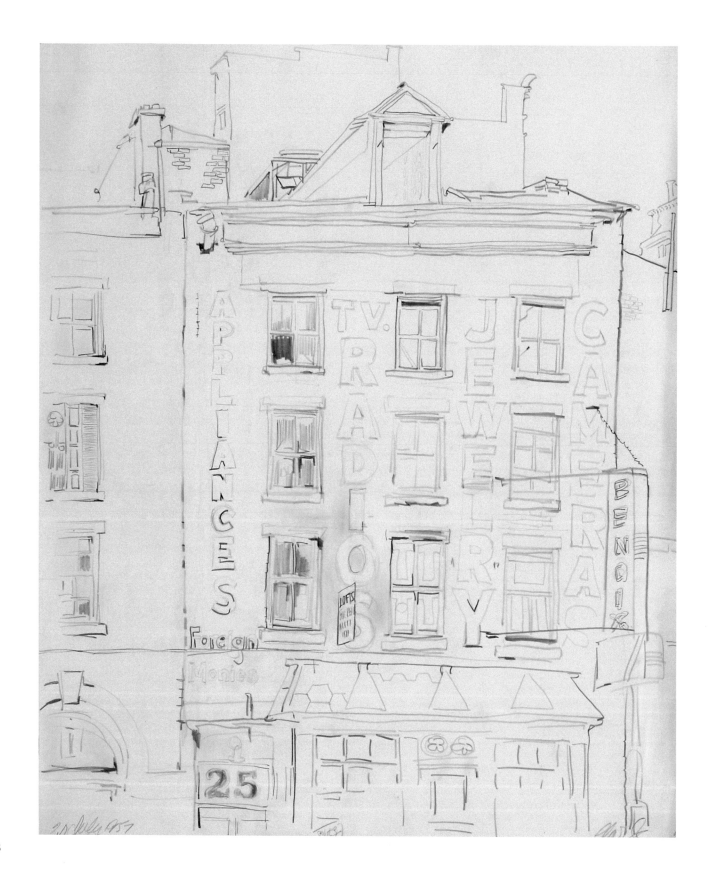

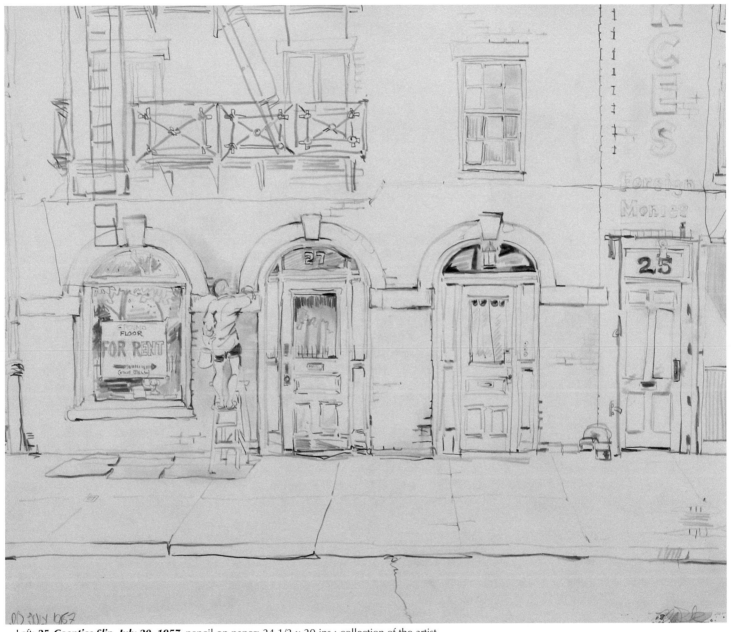

Left: **25 *Coenties Slip*, *July 20, 1957***, pencil on paper; 24 1/2 x 20 ins.; collection of the artist
Above: ***Jack Youngerman Cleaning the Front of His Loft on Coenties Slip, July 20, 1957***, pencil on paper; 20 1/2 x 24 1/2 ins.; collection of the artist

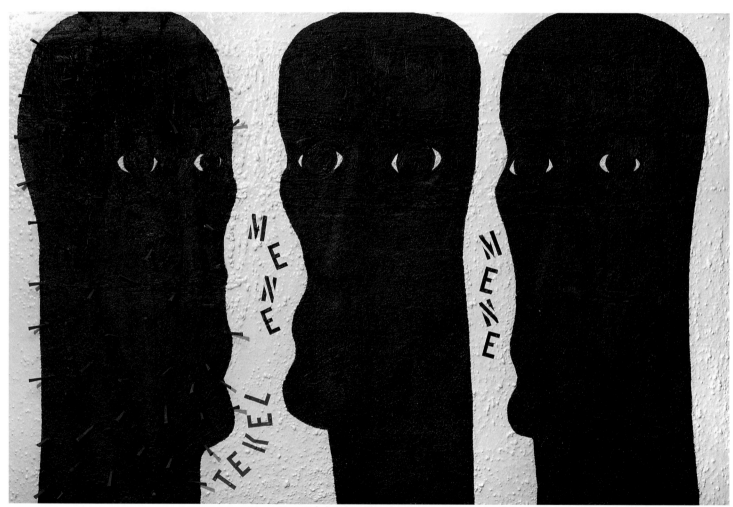

Mene Mene Tekel, 1955, oil on homasote with rusted nails; 38 1/2 x 57 3/4 ins.; collection of the artist

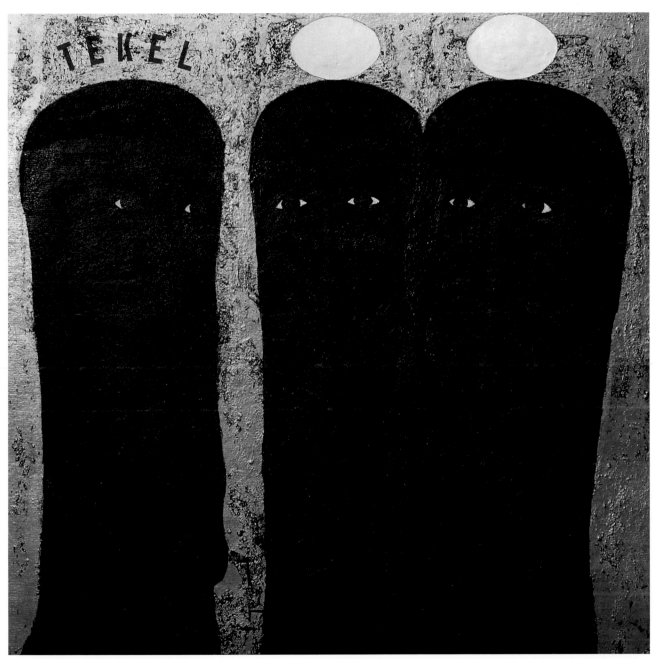

Tekel (*"Brothers"* **Odd Fellows**), 1954–1955, oil, gesso, sand, and gold leaf on homasote; 47 1/4 x 47 1/2 ins.; collection of the artist

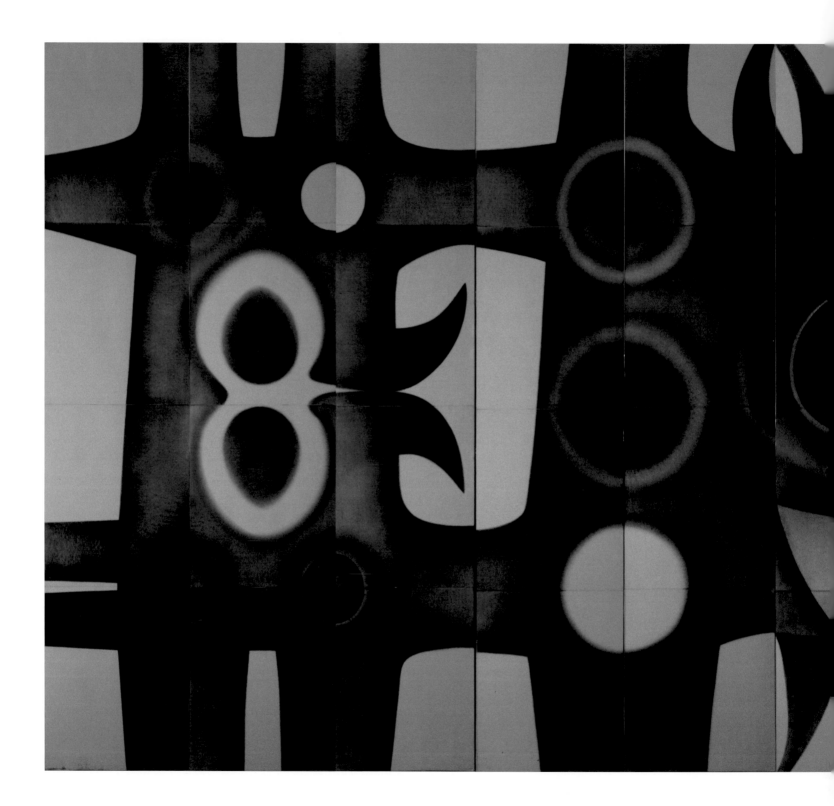

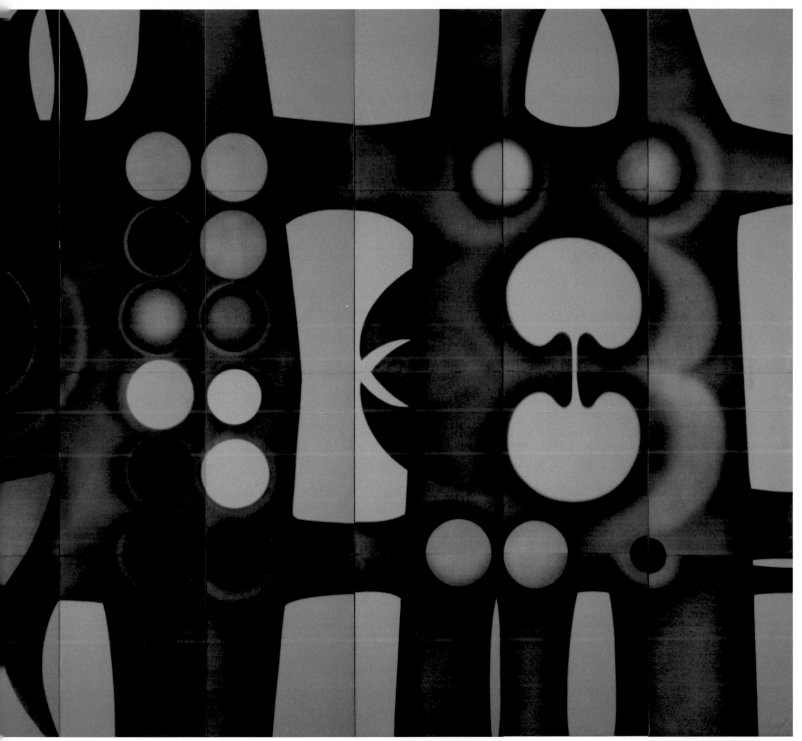

Stavrosis, 1958, printer's ink, dry brush on paper mounted on wood; 99 1/4 x 229 1/4 ins.; collection of the artist

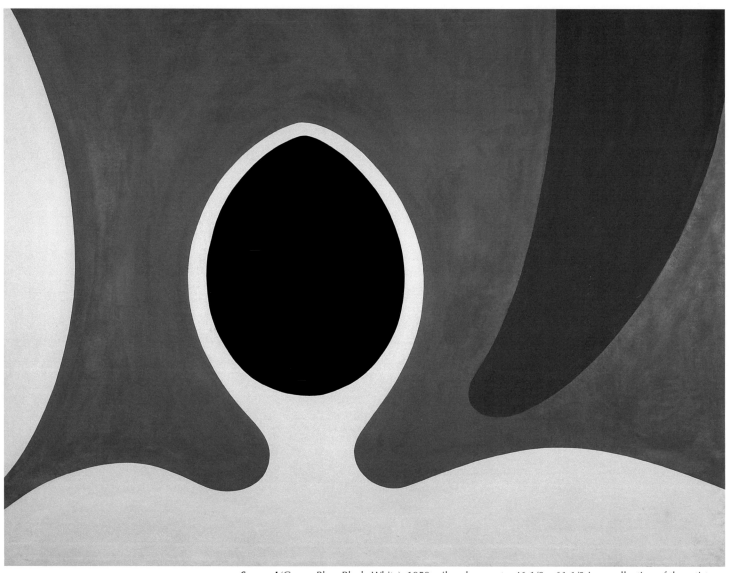

Source I (Green, Blue, Black, White), 1959, oil on homasote; 46 1/8 x 61 1/2 ins.; collection of the artist

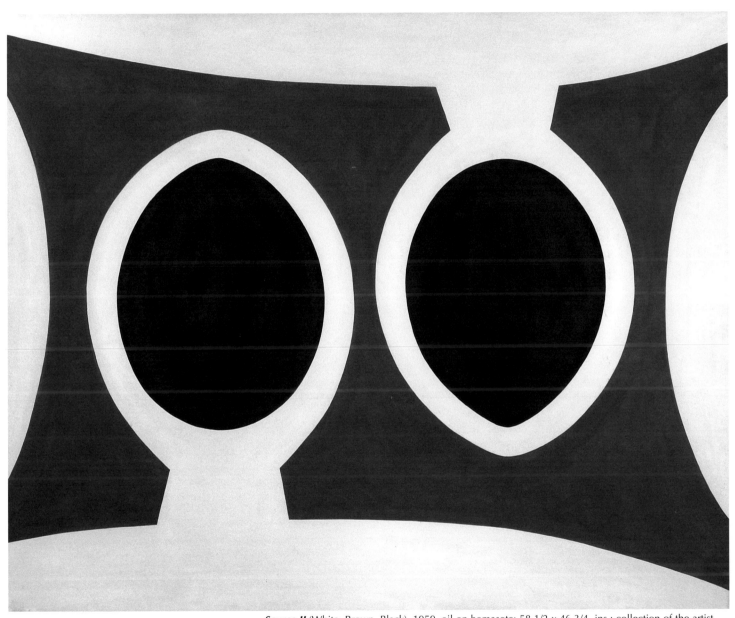

Source II (White, Brown, Black), 1959, oil on homasote; 58 1/2 x 46 3/4 ins.; collection of the artist

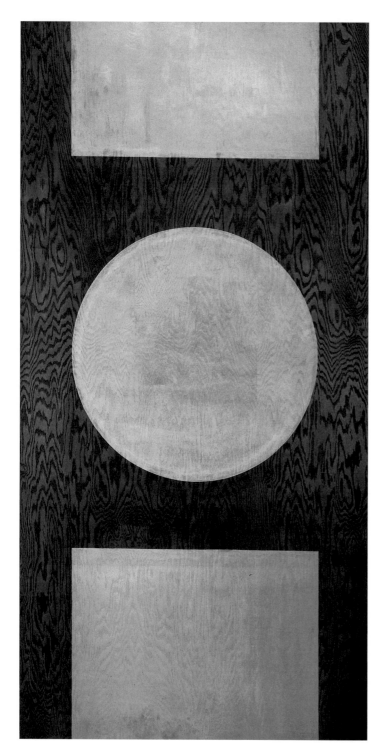
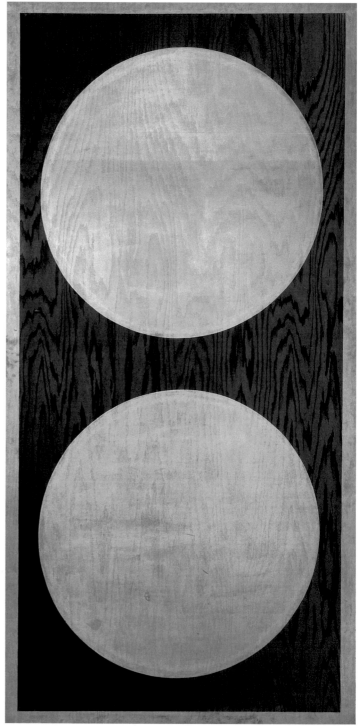

Left: ***One Golden Orb***, 1959-2007, oil on plywood; 96 x 48 ins.; collection of the artist
Right: ***Two Golden Orbs***, 1959-2007, oil on plywood; 96 x 48 ins.; collection of the artist

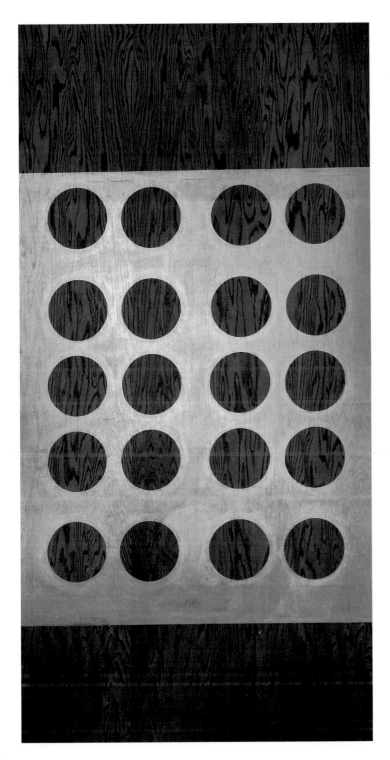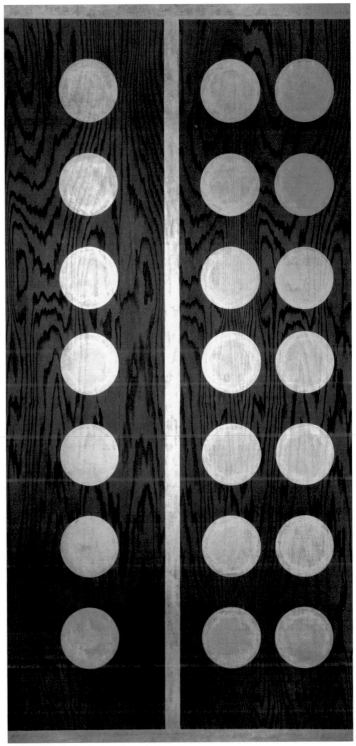

Left: ***Twenty Golden Orbs***, 1959-2007, oil on plywood; 96 x 48 ins.; collection of the artist
Right: ***Twenty-One Golden Orbs***, 1959-2007, oil on plywood; 96 x 48 ins.; collection of the artist

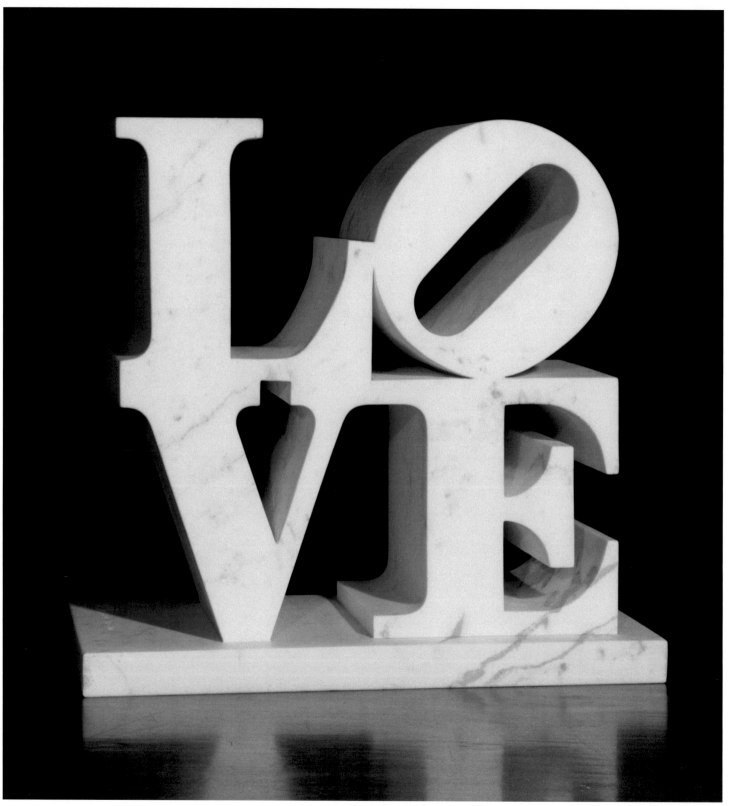

78 *LOVE*, 1966-2000, Carrara marble; 21 1/2 x 23 x 13 1/4 ins; collection of the artist

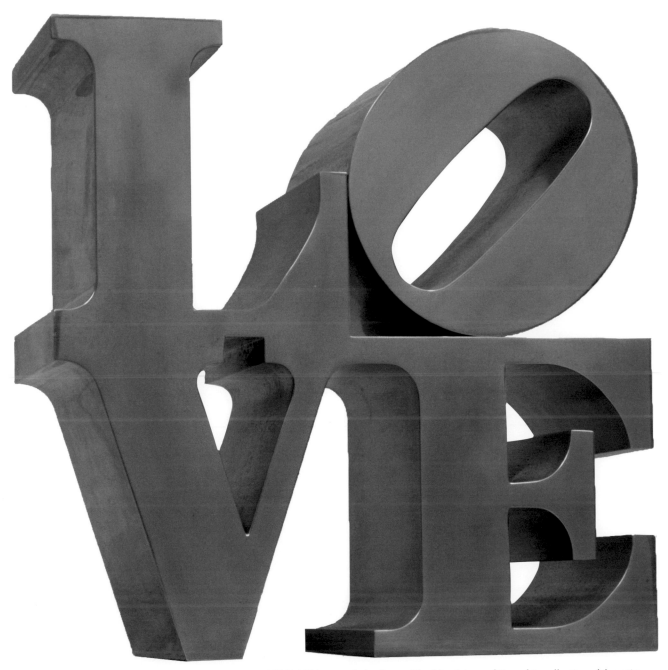

LOVE, 1966, carved aluminum; 12 x 12 x 6 ins.; edition of 6; collection of the artist

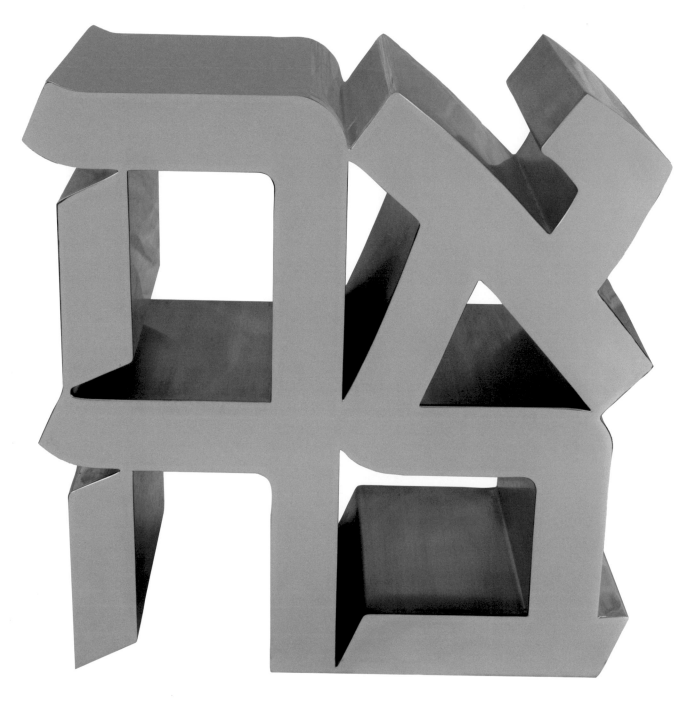

AHAVA, 1977–1997, stainless steel; 18 x 18 x 9 ins; edition 2/8 (From an edition of 8 plus 2 APs); collection of the artist

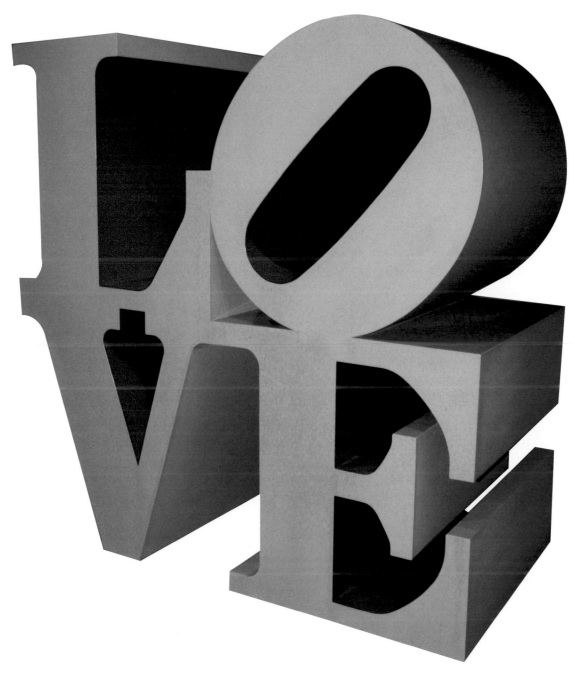

LOVE, 1996, Blue Outside Red Inside, polychrome aluminum; 72 x 72 x 36 ins.;
Edition 6/6 (from an edition of 6 plus 4 APs); Farnsworth Art Museum purchase, 1999

WHEN THE WORD IS LOVE

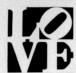

Dent the head
With the word.
See the lettered scar
on the skull.
On the bone
[In the beginning]
The straight line
Wherefrom the rounding
Circle is begat,
But, on our tongues
Never sat.
Yet see the jutting
Diags do, -
Ascendency inversed,
And in the final due,
Lo: the single stroke
Rampant three pronged
Trinity into Infinity.

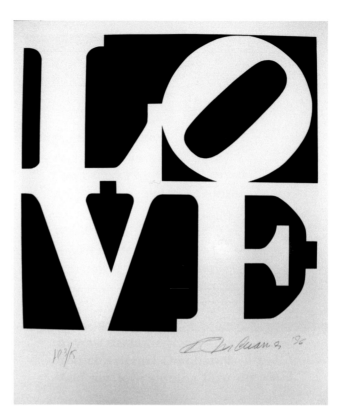

IN APAEAN

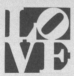

There were you
And flaye'd I
You called night transparent
And saw a skeleton of stars.

When I had bled
A pool to lie in
You called the day opaque
And bore chaste entrails to the sun.

With twilight
In your arms
You christened Diaphanor
And saw love shining thru my skull.

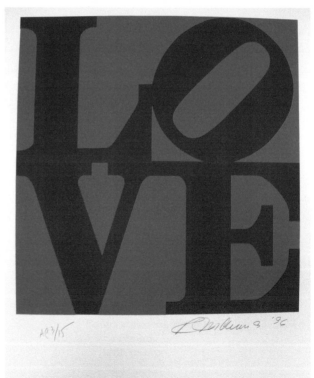

Pages 82–87 and 120: *The Book of Love*, 1*2 Poems and 12 Prints,* 1996; 26 x 20 1/2 ins.; Farnsworth Art Museum, gift of the artist

LOVE: Enflame.

Anoint my head with clove
That, hungry, love may rove
And stab like fire
The orifices of desire,
Lick the mated ear,
The married eye,
The bedded nose -
And leap white lavan
From the single rose
Of mouth.
Singe the skull,
Cause brain to boil.
Ignite my hair -
Enfurl a glowing anadem
Aromatic
With passion.

AP 3/15

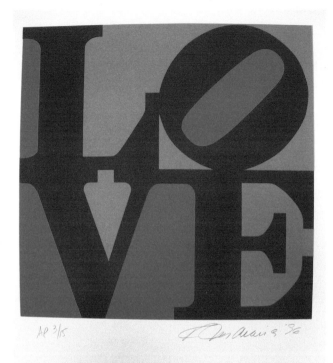

AP 3/15

QUIET, THE DOVE

From Alph
Our love-strewn aviary
How angels spring
To agitate the day.
Fingers flail
But fail the total feather.
Fingers thrall the heart
To bird to wing.
Where see the broken wicker
Discage, yet tear the flesh.
In vain deft fingers
Dry the rain
Pluck the ariel
To fluttering pieces-
Zed fell.

Quiet Dove!
The ark
Is dark.

AP 3/15

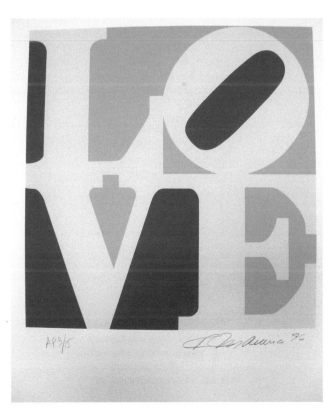

AP 3/15

TO DRAW A STRAIGHT LINE

To draw a straight line
when the skin yields like love
Beneath the glyph's caress -
To entice tatoo astray:
Is improbable artistry.
The flesh coronates itself Art.

To indraw the curved line
When the flesh balks ire
Foursquare the nerves deploy -
To resist the arc's trespass:
Is illogical progression.
The flesh knows its own design.

To bedraw a line to glory
When the skin reads to Hell
Corrupt the quilt of deceit
To confound the oracle:
Is indubitable folly.
The flesh insists to be the Fool.

AP 3/15

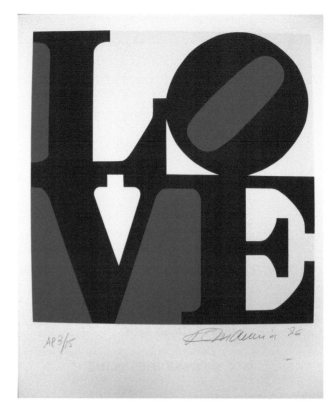

AP 3/15 R Indiana '86

FROM THE UMBRAGE OF A MASTER POET

To love poet and poet be-loved
Are the sun, the moon
Transfixed to metaphor.

To poet love
Is Word give
Sun life to live.

Whereas:
Poet be-loved
Is Light steal
Wax death to real.

Either elicit heavenly trial.

AP 3/15

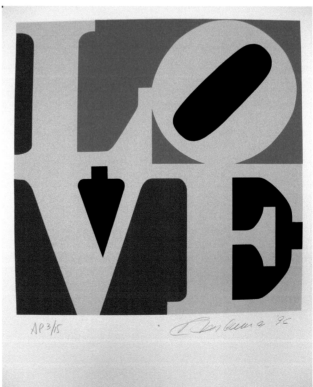

AP 3/15 R Indiana '86

MY LOVE, MY LOVE IS GONE TO YOU

My love, my love is gone to you
Like two faces that cannot but turn
Into each other warm and fierce
Whose lips are mated flowers.
The long petals growing
Knowing search for their suns,
Beloving.

AP 3/15

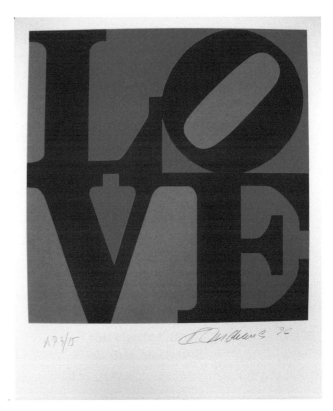

AP 3/15

THIRST

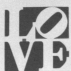

Come , Love, from snowy
highlands
Your journey sing
Down Moorlands and
tawny heather
To that black spring.

Come, Love, from
whitely breasts
Your journey tell
down torso and
the curving rib
To that black well.

AP 3/15

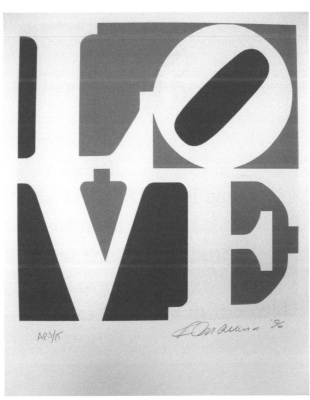

AP 3/15

THE WORD

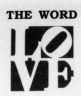

's Death
The Ancient Angel said.
's Christ
Cried the Miraculant
's Love
Mutters the Fool in the cold.

AP 3/15

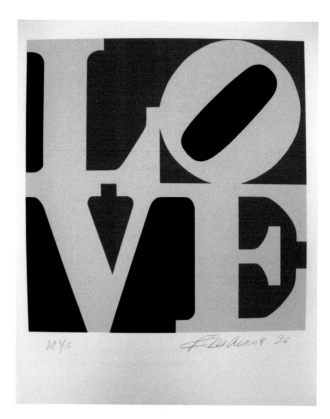

AP 3/15

TIGER MUSIC

O Undressed lovingly O
Virilence athwart the thought
Longly caressed in mind
Undrest the naked harp
Whose lean strings I pluck
And pull the tiger blazing
Musickly
From the green lair
To orchestrate love -
Andante the undulating ribbon
Of his tawny theme,
The rhythmic meat and bone
Of a flexe'd jungle chord.
Dark song devour me nude
Chant carnivorous love
O Animalled amour.

AP 3/15

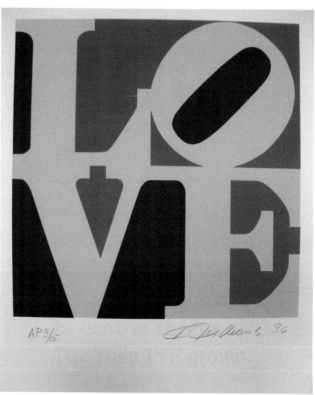

AP 3/15

PELVIC AND BRIGHT

Pelvic and bright

The rose I hold

Athwart my thighs

So red blooms bold

For summer's sighs

Sweet love's behold

Let crown the skies

In centric throne

The rose I've grown.

AP 3/15

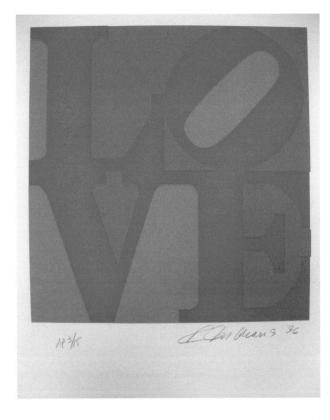

AP 3/15

WHEREFORE THE PUNCTUATION
OF THE HEART

Wherefore the punctuation of the heart
When that slim prim agape
LOVE
Erred into
L, O, V, E,
Encomma'd in uncertainty,
Is neither
L; O; V; E;
Haltered in some Philistine design;
Nor
L: O: V: E:
Encumbered in even deeper discelebration:
Let not
L/O/V/E/
Staggered stumble unrequitedly/
Quite not
L-O-V-E-
Shackled in measured irony —
Should not be
(L) (O) (V) (E)
(Buttressed incarceration)
But most not
L. O. V. E.
Hated anagram of death.
Instead quoth
"L" "O" "V" "E"
Not "nevermore" for "evermore"

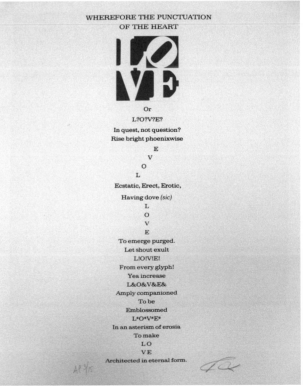

WHEREFORE THE PUNCTUATION
OF THE HEART

Or
L?O?V?E?
In quest, not question?
Rise bright phoenixwise
E
V
O
L
Ecstatic, Erect, Erotic,
Having dove *(sic)*
L
O
V
E
To emerge purged.
Let shout exult
L!O!V!E!
From every glyph!
Yea increase
L&O&V&E&
Amply companioned
To be
Emblossomed
L*O*V*E*
In an asterism of erosia
To make
L O
V E
Architected in eternal form.

AP 3/15

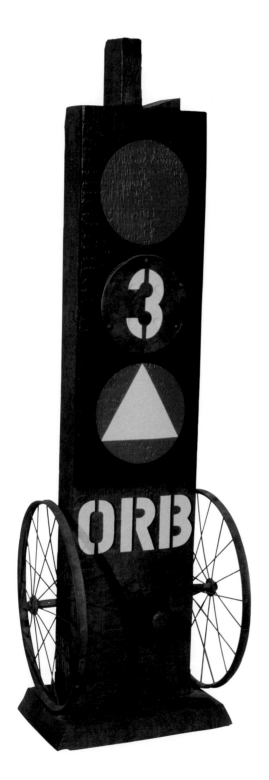

Orb, 1960–1991, AP 1/2, painted bronze; 60 1/2 x 20 x 19 ins.;
collection of the artist

Ge, 1960–1991, AP 1/2, painted bronze;
57 1/2 x 20 x 11 ins.; collection of the artist

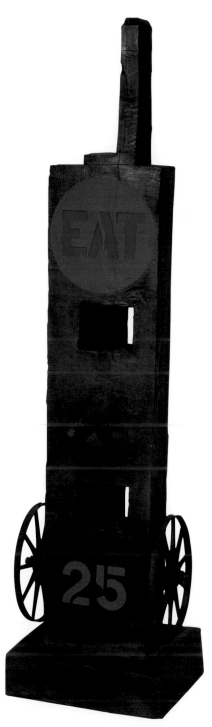

EAT, 1962–1991, AP 1/2, painted bronze;
59 x 15 1/2 x 12 ins.; collection of the artist

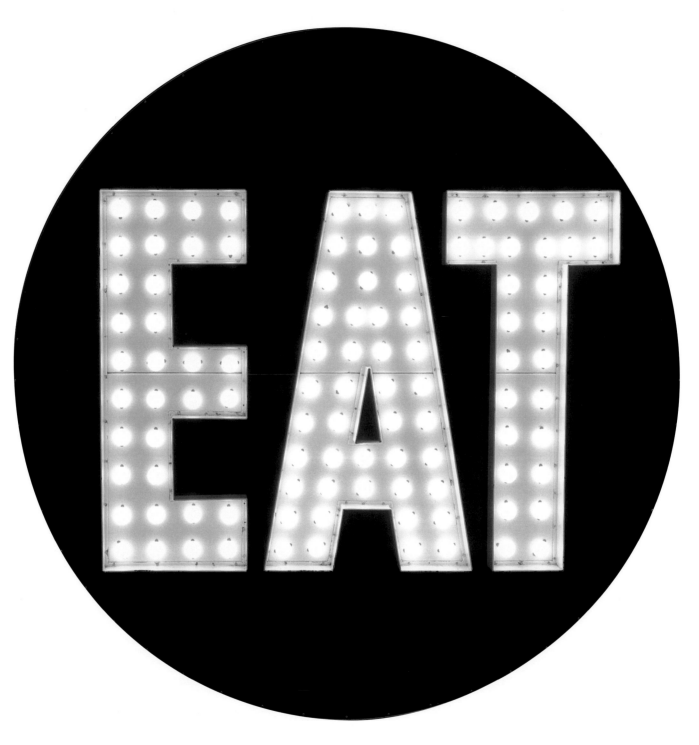

Electric EAT, 1964, painted metal with electric lights; diameter: 72 ins.; collection of the artist

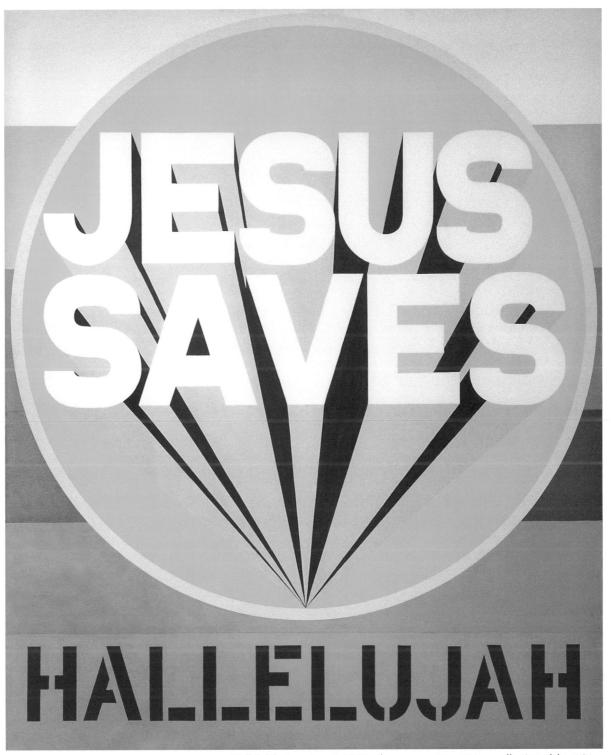

Hallelujah (Jesus Saves), 1969, oil on canvas; 60 x 50 ins.; collection of the artist

ART, 1972–1993, polychrome aluminum, AP 2/2; 12 x 12 x 6 ins.; collection of the artist

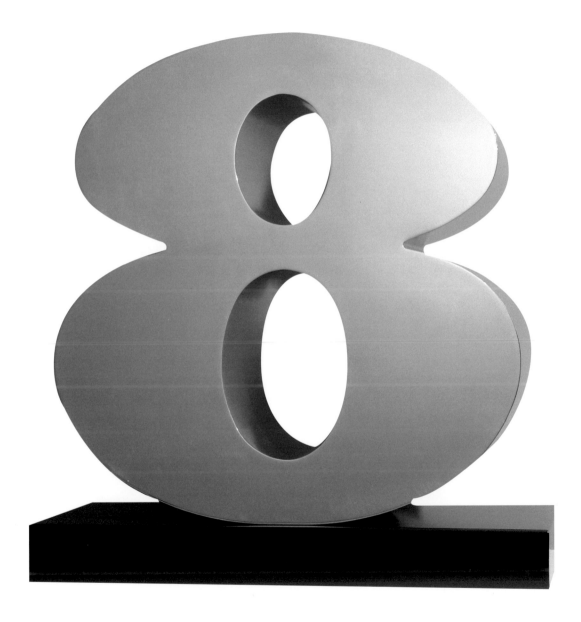

Eight, 1973–2003, stainless steel on painted steel base; 33 3/4 x 33 x 17 ins.; Edition HC I/II; collection of the artist

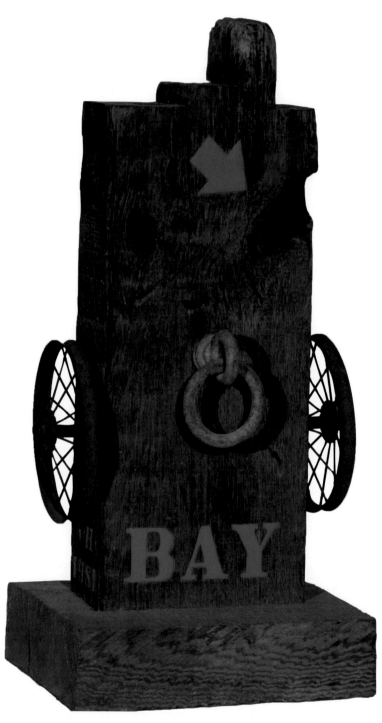

BAY, 1981, iron and oil on wood; 30 1/2 x 15 1/2 x 11 3/4 ins.; collection of the artist

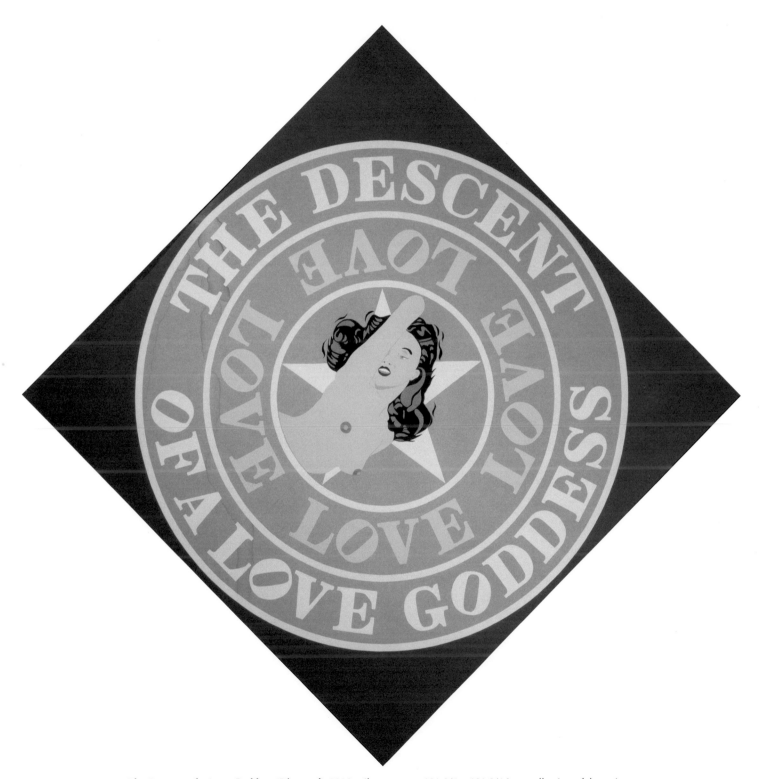

The Descent of a Love Goddess (Diamond), 2000, oil on canvas; 101 3/4 x 101 3/4 ins.; collection of the artist

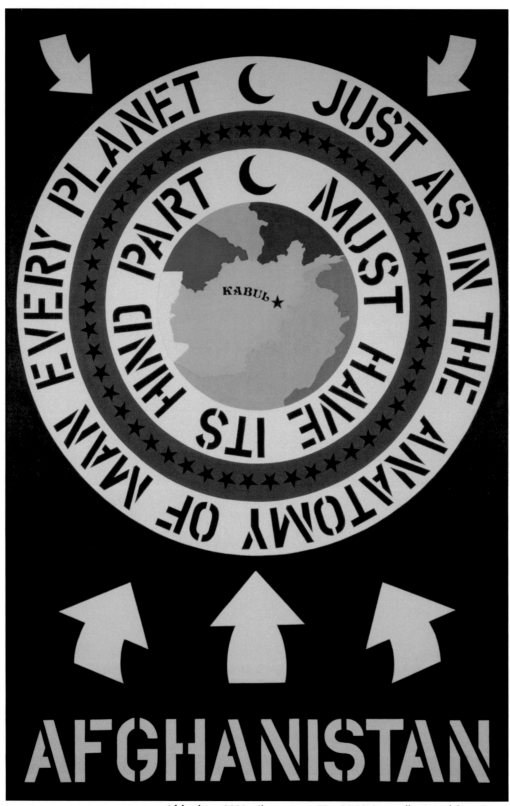

Afghanistan, 2001, oil on canvas; 77 x 50 3/4 ins.; collection of the artist

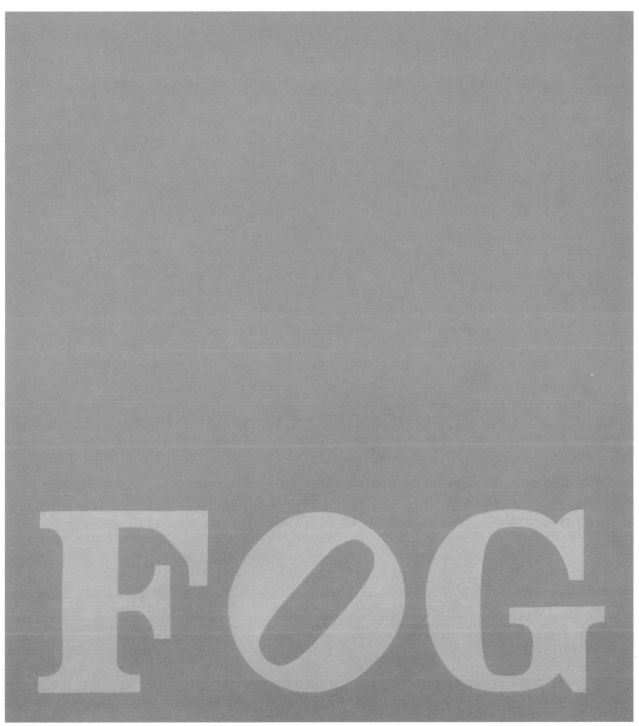

FOG, 1993, oil on canvas; 28 1/8 x 22 ins.; collection of the artist

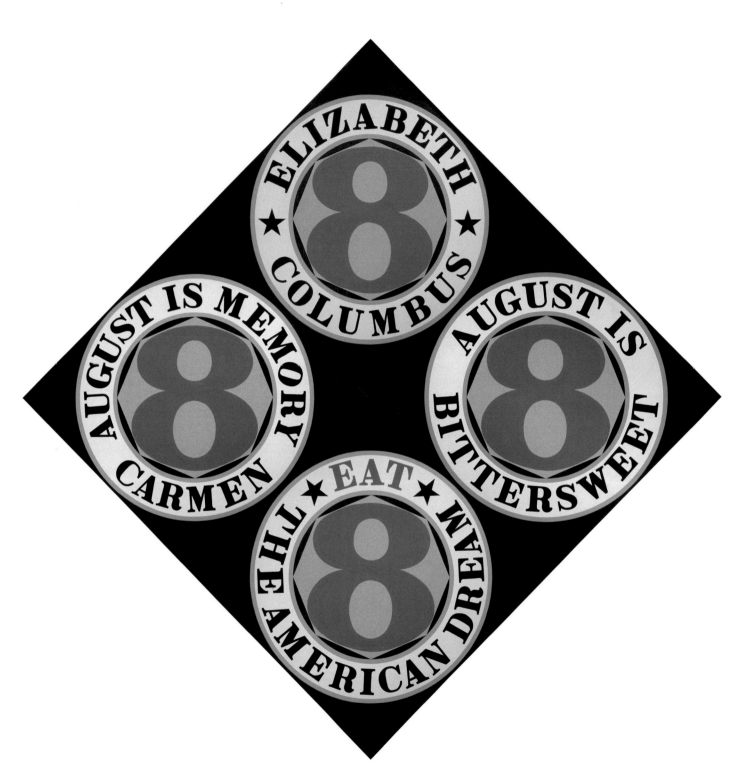

The Eighth American Dream, 2000; (4-panel diamond); oil on canvas; 170 x 170 ins.; collection of the artist

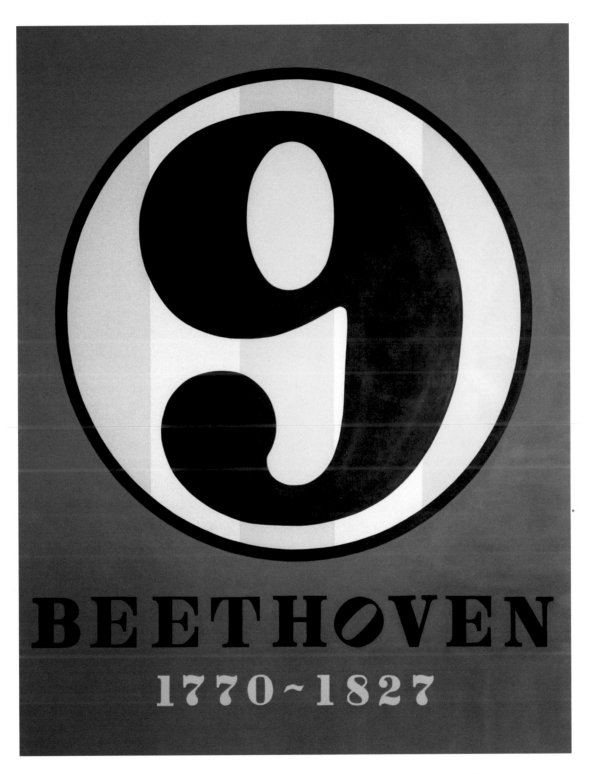

Beethoven, 2000, oil on canvas; 60 x 48 ins.; collection of the artist

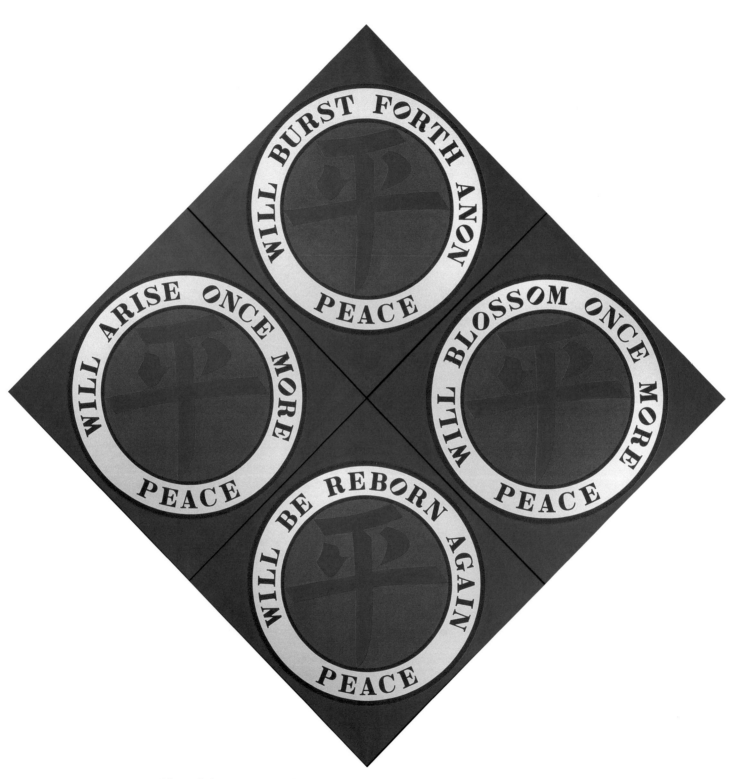

Diamond Ping, 2003, (4-panel diamond) oil on canvas; 102 x 102 ins.; collection of the artist

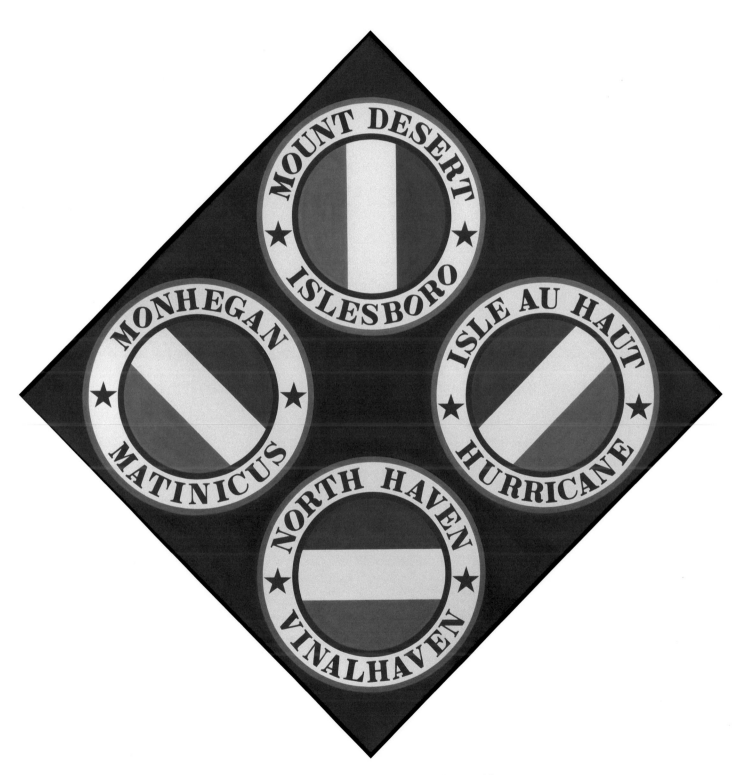

The Islands, 2002, oil on canvas; 63 x 63 ins.; collection of the artist

New Easel, 2002, oil on canvas; 77 x 51 1/4 ins.; collection of the artist

Chinese LOVE (yellow on red), 2002, oil on canvas; 77 x 52 ins.; collection of the artist

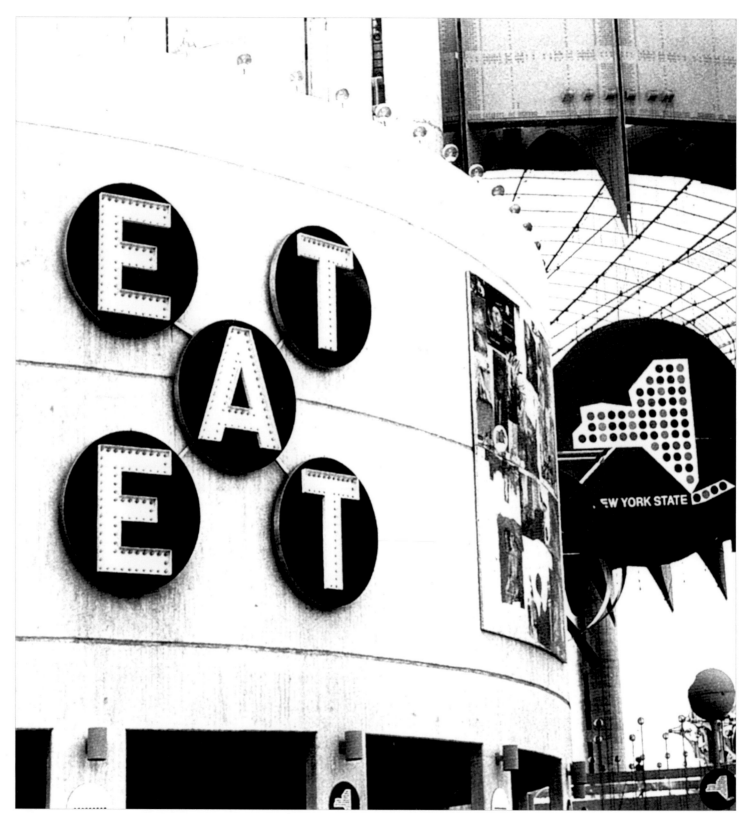

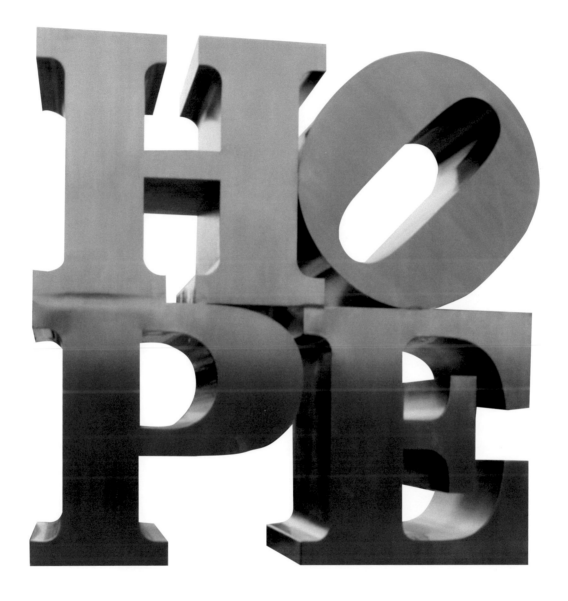

Left: **EAT**, 1964; painted and electrified steel; collection of the artist; photographed at the 1964
New York World's Fair, New York State Pavilion
Above: **HOPE**, 2008; stainless steel; 72 x 72 x 36 inches; collection of Michael Mackenzie

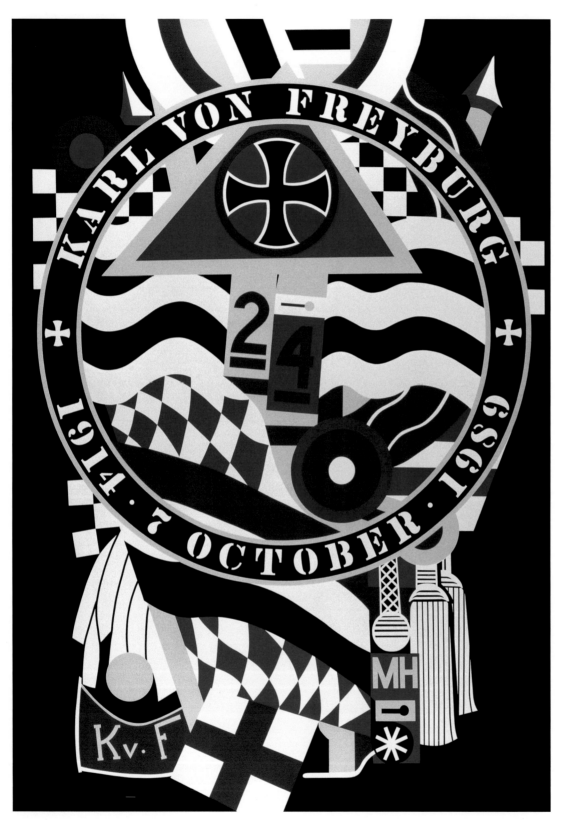

The Hartley Elegies:
The Berlin Series KvF I, 1990,
serigraph, 76 x 53 3/8 ins.;
collection of Bates College
Museum of Art; gift of the artist

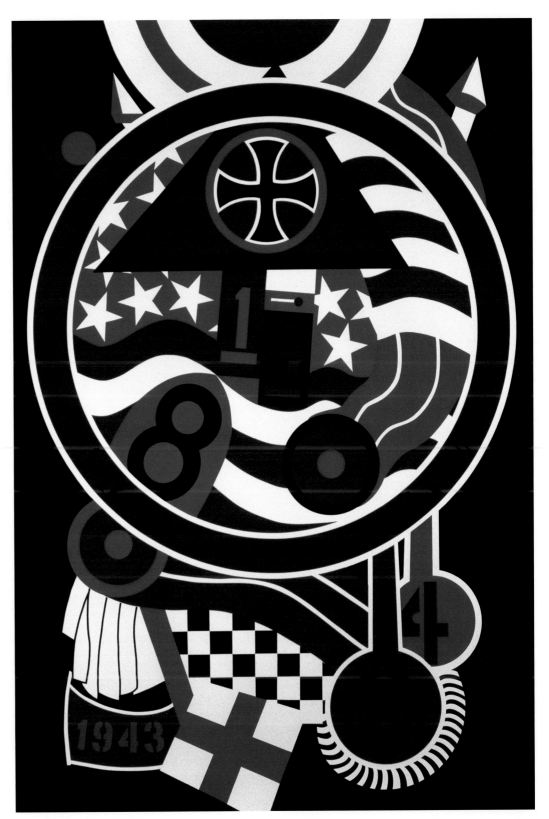

The Hartley Elegies:
The Berlin Series KvF II, 1990,
serigraph; 76 3/4 x 53 ins.;
collection of Bates College
Museum of Art; gift of the artist

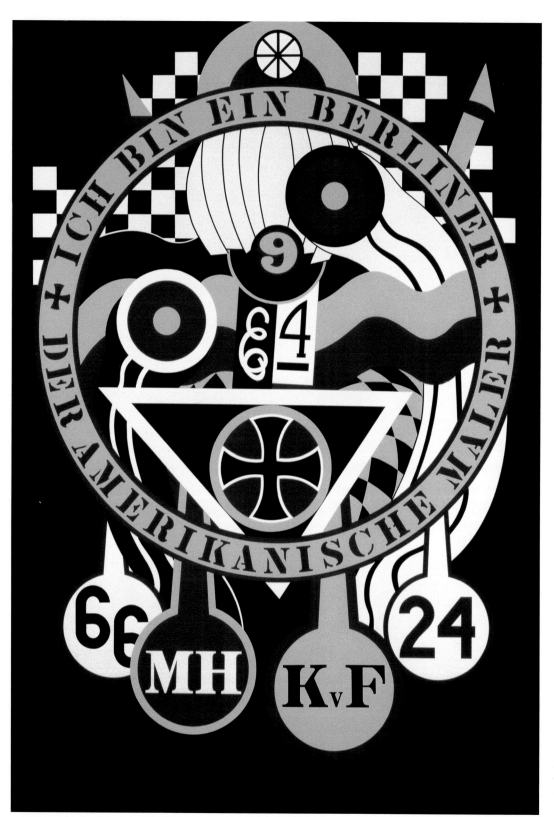

The Hartley Elegies:
The Berlin Series KvF III, 1990,
serigraph; 76 3/4 x 53 ins.;
collection of Bates College
Museum of Art; gift of the artist

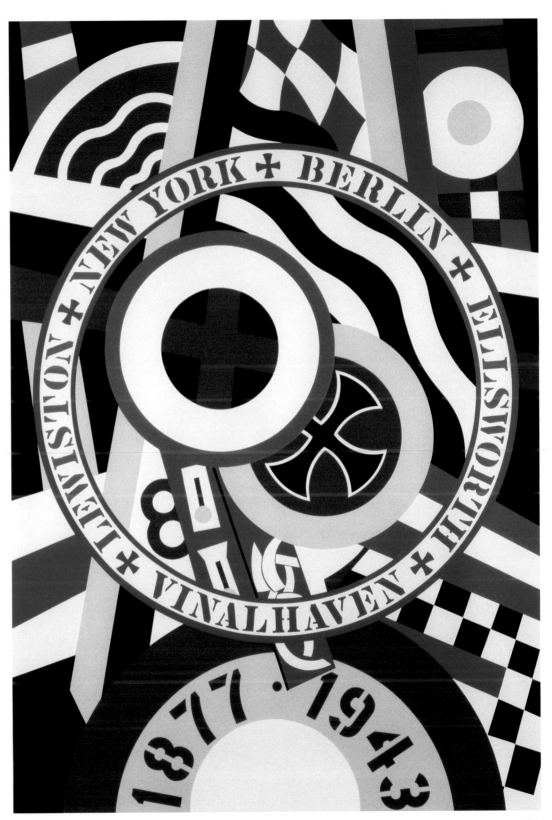

The Hartley Elegies:
The Berlin Series KvF IV, 1990,
serigraph; 77 1/8 x 53 ins.;
collection of Bates College
Museum of Art; gift of the artist

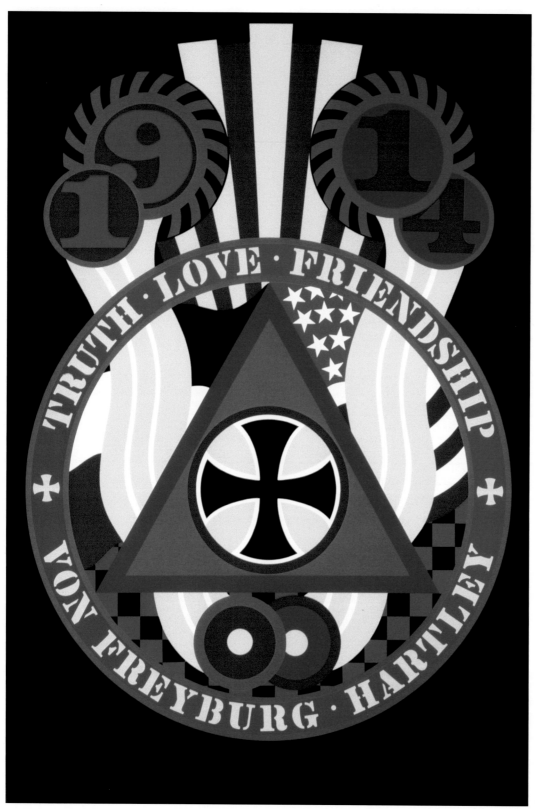

The Hartley Elegies:
The Berlin Series KvF V, 1990,
serigraph; 77 1/4 x 53 ins.;
collection of Bates College
Museum of Art; gift of the artist

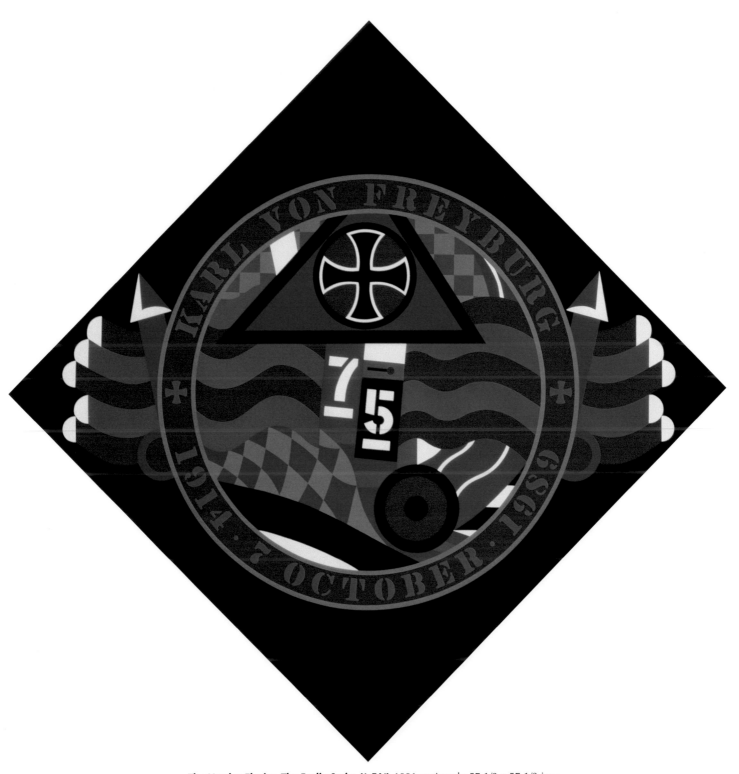

The Hartley Elegies: The Berlin Series KvF VI, 1991, serigraph; 57 1/2 x 57 1/2 ins.;
collection of Bates College Museum of Art; gift of the artist

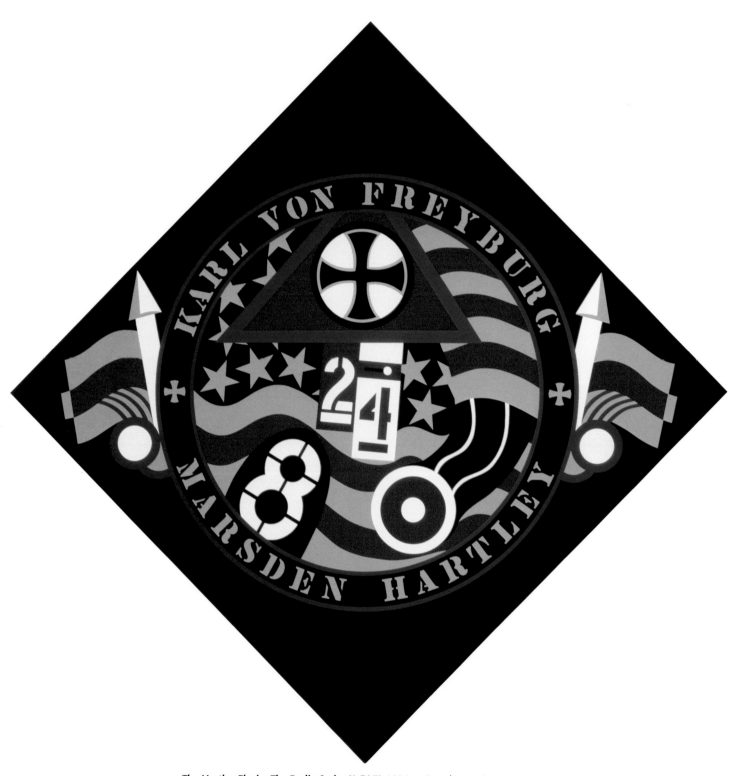

The Hartley Elegies The Berlin Series KvF VII, 1991, serigraph; 57 5/8 x 57 5/8 ins.;
collection of Bates College Museum of Art; gift of the artist

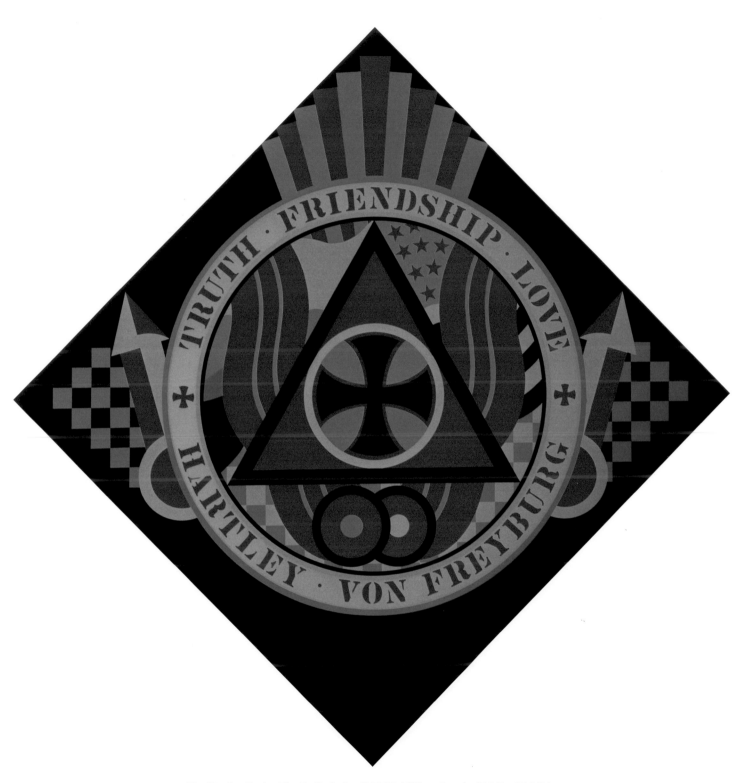

The Hartley Elegies: The Berlin Series KvF VIII, 1991, serigraph; 57 1/2 x 57 1/2 ins.;
collection of Bates College Museum of Art; gift of the artist

113

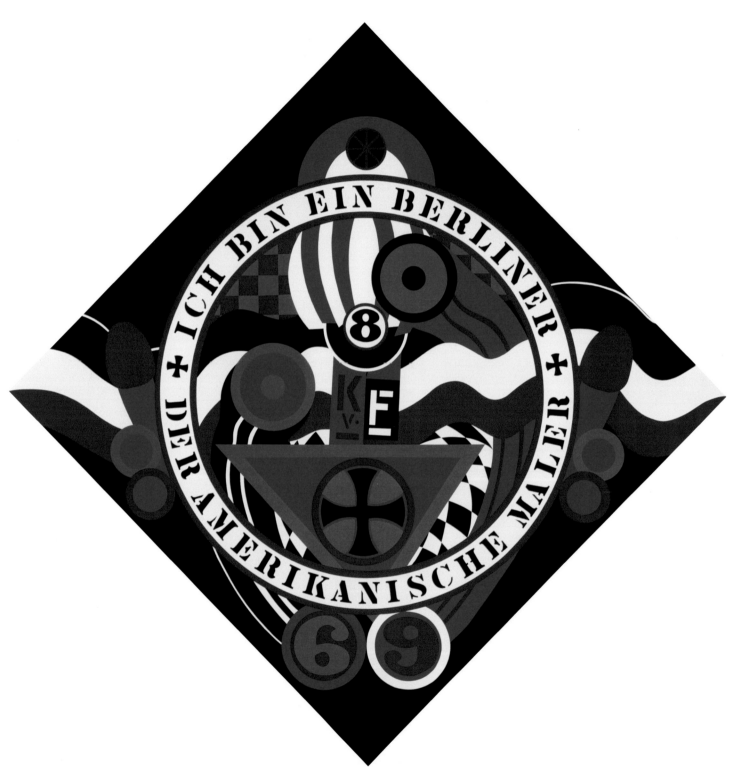

The Hartley Elegies: The Berlin Series KVF IX, 1991, serigraph; 57 5/8 x 57 5/8 ins.;
collection of Bates College Museum of Art; gift of the artist

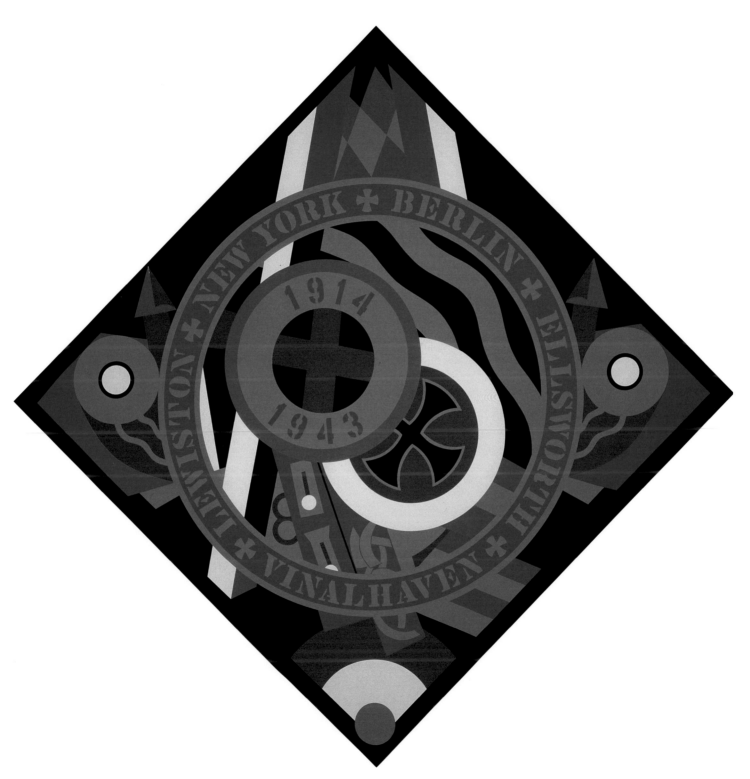

The Hartley Elegies: The Berlin Series KvF X, 1991, serigraph; 59 1/2 x 59 1/2 ins.;
collection of Portland Art Museum, Maine; gift of Park Granada Editions, 1991

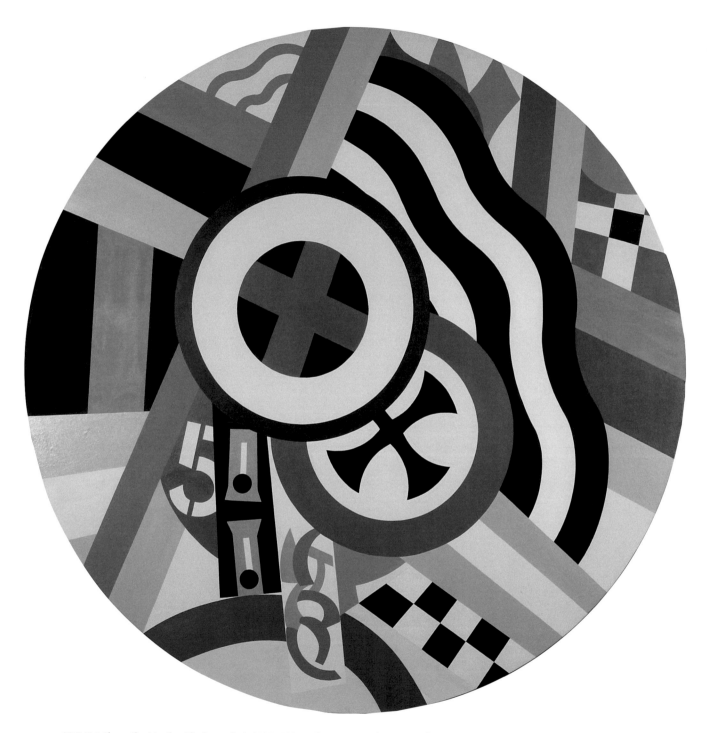

KVF XvI (from the Hartley Elegies series), 1989–1994, oil on canvas, diam 60 inches (tondo), collection of Morgan Art Foundation

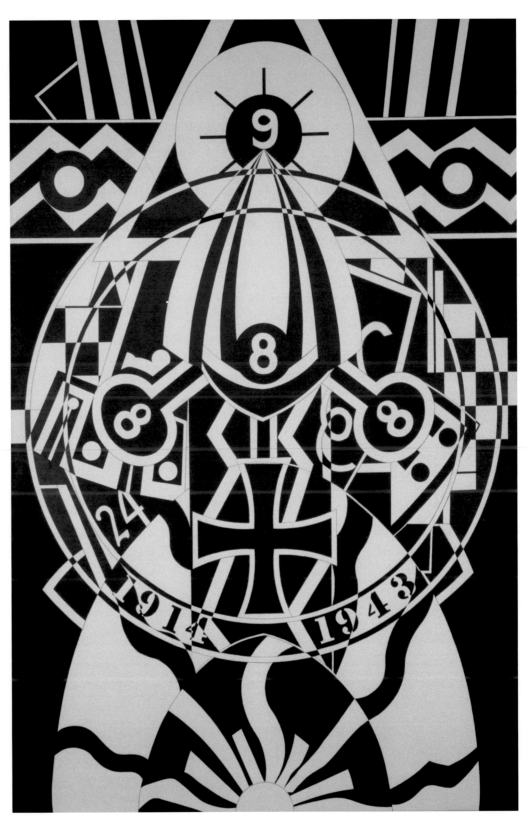

KvF VI
(from the Hartley Elegies series),
1989–1994,
oil on canvas, 77 x 51 ins.,
collection of Morgan Art Foundation

117

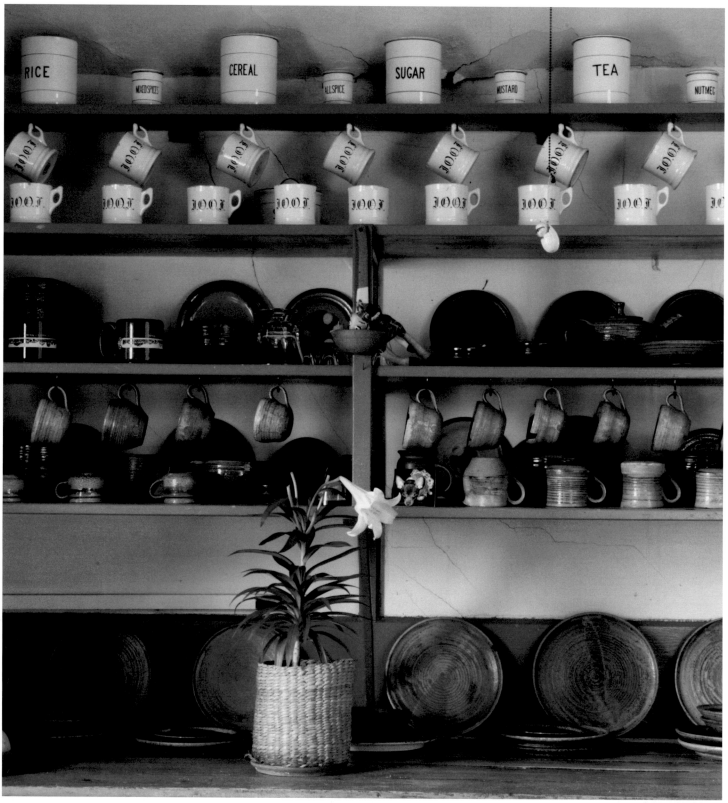

Star of Hope kitchen

EXHIBITION CHECKLIST
CATALOGUE INDEX
DIRECTOR'S AFTERWORD

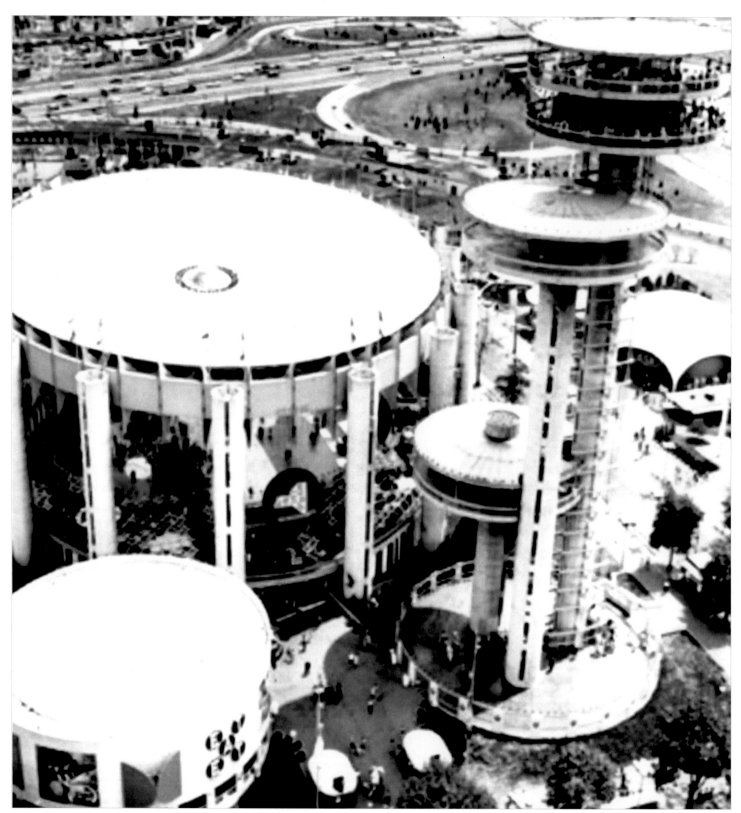

Aerial photograph of the 1964 New York World's Fair, with **EAT** shown lower left on the New York State Pavilion; photo, collection of artist

EXHIBITION CHECKLIST

25 Coenties Slip, July 20, 1957
Pencil on paper
24 1/2 x 20 ins.
Collection of the artist

Untitled (Railroad signal station,
Indianapolis, a few blocks from
Arsenal Tech High School),
c. 1945–1946
19 1/4 x 23 1/2 ins.
Pen, ink, and watercolor on paper
Collection of the artist

Afghanistan, 2001
Oil on canvas
77 x 50 3/4 ins.
Collection of the artist

AHAVA, 1977-1997
Stainless steel
18 x 18 x 9 ins.
Edition 2/8
(from an Edition of 8 plus 2 APs)
Collection of the artist

August is Memory Carmen,
1963
(Diamond: Yellow, Black,
Brown, Blue)

Oil on canvas
34 x 34 ins.
Collection of the artist

ART, 1972–1993
Polychrome aluminum, AP 2/2
12 x 12 x 6 ins.
Collection of the Artist

ART, 1972–2001
Red Blue Polychrome aluminum
102 x 97 x 50 ins.
Edition 4/5
(From an Edition of 5 plus 2 APs)
Collection of Morgan Art
Foundation
Courtesy Simon Salama-Caro

BAY, 1981
Iron and oil on wood
30 1/2 x 15 1/2 x 11 3/4 ins.
Collection of the artist

Beethoven, 2000
Oil on canvas, 60 x 48 ins.
Collection of the artist

The Book of Love, 1996
12 Poems and 12 Prints
26 x 20 1/2 ins.

Farnsworth Art Museum
Gift of the artist

Chinese LOVE, 2002
(Yellow on Red)
Oil on canvas
77 x 52 ins.
Collection of the artist

*Columbus: The Geography
of the Memory*, 1960–1992
Oil on canvas, 42 x 31 ins.
Collection of the artist

The Descent of a Love Goddess
(Diamond), 2000
Oil on canvas
101 3/4 x 101 3/4 ins.
Collection of the artist

Diamond Ping, 2003
(4-panel diamond)
Oil on canvas
4 panels, 102 x 102 ins.
Collection of the artist

Duncan's Column, c. 1961
Iron, oil, wood and stone
75 x 17 x 17 ins.
Collection of the artist

EAT, 1964
Painted and electrified steel
Collection of the artist

EAT, 1962–1991, AP 1/2
Painted bronze
59 x 15 1/2 x 12 ins.
Collection of the artist

Eight, 1973–2003
Stainless steel on painted steel base
33 3/4 x 33 x 17 ins.
Edition HC I/II
Collection of the artist

The Eighth American Dream,
2000
(4-panel diamond)
Oil on canvas
170 x 170 ins.
Collection of the artist

Electric EAT, 1964
Painted metal with electric lights
Diameter: 72 ins.
Collection of the artist

The First State to Hail the Rising Sun, 2002
Oil on canvas
60 x 60 ins.
Gift of the artist to the State of Maine; on loan by permission of Governor John E. Baldacci and the Maine Arts Commission

FOG, 1993
Oil on canvas
24 1/8 x 22 ins.
Collection of the artist

Ge, 1960–91, AP 1/2
Painted bronze
57 1/2 x 20 x 11 ins.
Collection of the artist

Hallelujah (Jesus Saves), 1969
Oil on canvas, 60 x 50 ins.
Collection of the artist

Hartley Elegy series Paintings
KvF VI, 1989–1994
Oil on canvas
77 x 51 ins.
Collection of Morgan Art Foundation

KvF XVI, 1989–1994
Oil on canvas
Diam 60 ins. (tondo)
Collection of Morgan Art Foundation

Hartley Elegy series Prints
The Hartley Elegies: The Berlin Series, KvF I, 1990
Serigraph
76 x 53 3/8 ins.
Courtesy of Bates College Museum of Art
Gift of the artist

The Hartley Elegies: The Berlin Series KvF II, 1990
Serigraph
76 3/4 x 53 ins.
Courtesy of Bates College Museum of Art
Gift of the artist

The Hartley Elegies: The Berlin Series, KvF III, 1990
Serigraph
76 3/4 x 53 ins.
Courtesy of Bates College Museum of Art
Gift of the artist

The Hartley Elegies: The Berlin Series KvF IV, 1990
Serigraph
77 1/8 x 53 ins.
Courtesy of Bates College Museum of Art
Gift of the artist

The Hartley Elegies: The Berlin Series KvF V, 1990
Serigraph
77 1/4 x 53 ins.
Courtesy of Bates College Museum of Art
Gift of the artist

The Hartley Elegies: The Berlin Series KvF VI, 1991
Serigraph
57 1/2 x 57 1/2 ins.
Courtesy of Bates College Museum of Art
Gift of the artist

The Hartley Elegies: The Berlin Series KvF VII, 1991
Serigraph
57 5/8 x 57 5/8 ins.
Courtesy of Bates College Museum of Art
Gift of the artist

The Hartley Elegies: The Berlin Series KvF VIII, 1991
Serigraph
57 1/2 x 57 1/2
Courtesy of Bates College Museum of Art
Gift of the artist

The Hartley Elegiess: The Berlin Series KvF IX, 1991
Serigraph
57 1/2 x 57 1/2 ins.
Courtesy of Bates College Museum of Art
Gift of the artist

The Hartley Elegies: The Berlin Series KvF X, 1991
Silkscreen on paper, edition 50
59 1/2 x 59 1/2 ins.
Portland Art Museum, Maine
Gift of Park Granada Editions, 1991

Hero, c. 1934
Crayon and pencil on paper
8 1/4 x 11 ins.
Collection of the artist

High Yaller, c. 1945
Watercolor, gouache and graphite
Signed in ink at bottom:
"Jo Ellen & The Bus Depot"
23 1/4 x 17 1/2 ins.
Collection of the artist

HOPE, 2008
Oil on canvas
36 x 36 ins.
Collection of the artist

HOPE, 2008
Stainless steel
72 x 72 x 36 ins.
Collection of Michael Mackenzie

The Islands, 2002
Oil on canvas
63 x 63 ins.
Collection of the artist

Jack Youngerman Cleaning the Front of His Loft on Coenties Slip, July 20, 1957
Pencil on paper
20 1/2 x 24 1/2 ins.
Collection of the artist

LOVE, 1966
Carved aluminum
12 x 12 x 6 ins.
Edition of 6
Collection of the artist

LOVE, 1966-2000
Carrara marble
21 1/2 x 23 x 13 1/4 ins.
Collection of the artist

LOVE, 1996
Blue Outside Red Inside
Polychrome aluminum
72 x 72 x 36 ins.
Edition 6/6
(from an Edition of 6 plus 4 APs)
Museum purchase, 1999

Robert Indiana
LOVE Wall, 1966–2006
Corten steel
144 x 144 x 48 ins.
Edition AP 2/2
(From edition of 3 plus 2 APs)
Collection of Morgan Art Foundation
Courtesy Simon Salama-Caro

Mene, Mene Tekel , 1950–1955
Oil on homasote with rusted nails
38 1/2 x 57 3/4 ins.
Collection of the artist

Monaco 7, 1997
Oil on canvas
60 x 50 ins.
Collection of the artist

Mother and Father, 1963–1967
Oil on canvas
Two panels, 72 x 60 ins. each
Collection of the artist

New Easel, 2002
Oil on canvas
77 x 51 1/4 ins.
Collection of the artist

New Glory Penny (diptych),
1963
Oil on canvas
15 1/4 x 13 ins.
Collection of the artist

New Glory Banner, 1999
Oil on canvas
91 1/4 x 60 ins.
Collection of the artist

Orb, 1960–1991, AP 1/2
Painted bronze
60 1/2 x 20 x 19 ins.
Collection of the artist

One Golden Orb, 1959–2007
Oil on plywood
96 x 48 ins.
Collection of the artist

*Two Golden Orb*s, 1959–2007
Oil on plywood
96 x 48 ins.
Collection of the artist

Twenty Golden Orbs,
1959–2007
Oil on plywood
96 x 48 ins.
Collection of the artist

Twenty-One Golden Orbs,
1959-2007
Oil on plywood
96 x 48 ins.
Collection of the artist

She He (diptych), 1970s
Oil on canvas
36 x 36 ins. each panel
Collection of the artist

Source I
(Green, Blue, Black, White),
1959
Oil on homasote
46 1/8 x 61 1/2 ins.
Collection of the artist

Source II
(white, brown, black), 1959
Oil on homasote
58 1/2 x 46 3/4 ins.
Collection of the artist

Stavrosis, 1958
Printer's ink, dry brush on paper
mounted on wood
99 1/4 x 229 1/4 ins.
Collection of the artist

Teke ("Brothers" Odd Fellows),
1950–1955
Oil, gesso, sand, and gold leaf
on homasote
47 1/4 x 47 1/2 ins.
Collection of the artist

Woman on a Bus, 1945
Pastel on paper
23 1/4 x 17 1/4 ins.
Collection of the artist

Duncan's Column, c. 2000, iron, oil,
wood and stone; 75 x 17 x 17 ins.;
collection of the artist

123

The First State to Hail the Rising Sun, 2002; oil on canvas; 60 x 60 ins.; gift of the artist to the State of Maine; on loan by permission of Governor John E. Baldacci and the Maine Arts Commission

CATALOGUE INDEX

2000 .. 27

"Absolute Happiness/is
 Two Glazed Donuts Forever" 29–30

129 Die in Jet (Warhol) 12

25 Coenties Slip, July 20, 1957 68

abstract expressionism 17

Afghanistan 14, 30, *96*

AHAVA 25, *80*

American Dietary, The 20

American Dream #1 14, 27

American Dream #7 27

American Dream series 27, 35

American Pop Opera, An 25

American Sweetheart, The 19, 20

AMOR .. 25

ART (1972–1993) *92*

assemblages 27, 29

August is Memory Carmen 12, *13*, 19

Barns on a Hillside 15

BAY 29, *94*

Beethoven 24, *99*

Berlin series. See *The Hartley Elegies.*

Black Marilyn, The 29

Book of Love, The 82–87, *120*

Bowery studio 51, 55–56

Calumet 11, 19

Campbell Soup series (Warhol) 12, 14

Cathedral of St. John
 the Divine (New York City) 15, 53

Chinese LOVE 25, *103*

Clark, Robert (Robert Indiana) 15

Coenties Slip 11, 15, 35, 55, *68–69*

color-field painting 27

*Columbus: The Geography
 of the Memory* 17, *18*

Confederacy series 12, 14, 19

Creely, Robert 24

Decade: Autoportraits series 24, 35

*Demuth American
Dream #5, The* 21, 27

Demuth series 24

Demuth, Charles 21, 25

*Descent of a Love Goddess,
 The* (Diamond) 29, *95*

Diamond Ping *100*

Duncan's Column *123*

Dine, Jim 14

Easel 17, 30

EAT 19, *104*

EAT (painted bronze) *89*

EAT/DIE (1962) 19, 20

EAT/DIE (1965) 12

Eight (stainless steel) *93*

Eighth American Dream, The 27, *98*

Electric EAT 19, *90*

Elisofon, Eliot 25, 35, 51

EROS 29, 58

Exploding Numbers 24

Figure 5, The 21

*First State to Hail
 the Rising Sun, The* 19, 27, 55, *124*

Fishermen's Last Supper,
 (Hartley) 17

FOG 29, 54, *97*

Ge (painted bronze) *89*

God Is a Lily of the Valley 35

Good Templars,
 International Order of 40

Grand Army of the Republic 40

Great American Nude
 series (Wesselman) 14

Hallelujah (Jesus Saves) 19, *91*

Hartley Elegies, The (paintings)
 11, 15, 17, 26–27, 54, *116–117*

*Hartley Elegies, The:
 The Berlin Series* (serigraphs)
 15, 17, 26–27, 54, *106–115*

Hartley, Marsden 17, 25, 26, 51, 53-54

herms 19, 27, 29

Hero *128*

Hic Jacet 12, 35

High Yaller 15, *16*

Hinman, Charles 15

HOLE 19, 27

Homes, Martin 38

HOPE (painting) *2*

HOPE (sculpture) *105*

HOPE series 30, 35

Indiana (state) 15, 19

Indianapolis 15, 55
Indiana's Indianas
 (Farnsworth Art Museum
 exhibition 1982) 52
Islands, The 27, 54, *101*
Jack Youngerman Cleaning
 the Front of His Loft on
 Coenties Slip, July 20, 1957 *69*
Jitterbug EAT. See *Electric EAT*
Kelly, Ellsworth 15, 17, 19
Kilby, Cyrus 41
Knights of Honor 40
Lasansky, Mauricio 51
Lichtenstein, Roy 12, 14, 19
LOVE (Carrara marble) *78*
LOVE (carved aluminum) *79*
LOVE series 14, 25, 30, 35
LOVE, Blue Outside Red Inside
 (polychrome aluminum) *81*
Maine 27, 40, 54
Marilyn series 29
Marin, John 25, 51
Martin, Agnes 15, 55
Masons, Order of 50
Melville Tryptic, The 11, 19, 27
Mene Mene Tekel 17, *70*
Metamorphosis of Norma
 Jean Mortenson, The 12, 19, 29
minimalism 17, 27
Monaco 7 27, *28*
Monroe, Marilyn 12, 29
Montreal Expo (1967) xx
MOON 19, 27
Mother and Father 21, *22–23,* 29, 58
Mother of Exiles 53, *53*
Mother of Us All, The 25
Ms. America 29
Museum of Modern Art 25, 27
Nesbitt, Lowell 57, 58
Nevelson, Louise 15, 56
New Castle 19
New Easel 30, *102*
New Glory Banner 20, *20,* 35
New Glory Penny 20, *21*
New York World's Fair. See World's Fair.
Nick, Pat 52
Ninth American Dream 14
Numbers series 24

Odd Fellows, International
 Order of 35–47, 48–51, 54–58
Odd-Fellowship Exposed (anon.) 37–38, *37*
One Golden Orb *76*
op art 17, 27
Orb (painted bronze) *88*
Orb paintings 17, *76–77*
Peace series 12, 15
Pop art 11, 12, 14, 17, 19
Portrait of a German Officer (Hartley) 26
PREM *25*
President, The (A Divorced Man
 Has Never Been President) 19
Protractor (Stella)17
Racz, André 51
Rauschenberg, Robert 19
Red Race Riot (Warhol) 12
Red Sails 19
Reflection series (Lichtenstein) 14
Reform Club 40
Reversals (Warhol) 14
Ridgely, James L. 49, 50, *50*
Rock of Odd Fellowship, The *49,* 49–50
Rosenquist, James 12, 14, 15, 17
Ryan, Susan Elizabeth 15, 54, 55
Sanasordo, Paul 17
Seventh Dream 27
She He *24*
Slips, The 19
Source I 17, 19, *74*
Source II *75*
Soyer, Raphael 51
Star of Hope Lodge #42
 39–42, 48, 49, 51
Star of Hope lodge (home
 and studio) 12, 25, 35, 36, 51, 54–58
Stavrosis 15, *72–73*
Stella, Frank 17
Suicide (Warhol) 12
Sunset Nudes (Wesselman) 14
Sweet Mystery, The 19, 30
Tekel *17*
Terra Haute 19
Terra Haute #2 19
Triumph of Tira, The 19, 20
Thirteen Most Wanted Men (Warhol) 19–20
Thurston, Stephen 37, 38, 41
Twenty Golden Orbs *77*

Twenty-One Golden Orbs *77*
Two Golden Orbs *76*
Tyrone Guthrie Theater 25
Untitled (railway signal
 station, Indianapolis) *67*
USA/Perigee 12
van Bruggen, Coosje 14
Vinalhaven 11, 35, 39–40, 48, 51, 52
Vinalhaven Press 52
von Freyburg, Karl 54
Warhol, Andy 12, 14, 19–20
Wesselman, Tom 14
Wildey, Thomas *36,* 50
Williams, William Carlos 24
Woman on a Bus 15, *66*
Women's Christian Temperance Union 40
World's Fair (1964) 19–20
Yale Lipstick (Oldenburg) 14
Year of Meteors 11, 19
Yield Brother 30
Youngerman, Jack 15, 17, *69*
Zeus/Zero 29, 57–58,

DIRECTOR'S AFTERWORD

by Michael K. Komanecky

Interim Director and Chief Curator, Farnsworth Art Museum

The Farnsworth Art Museum's relationship with Robert Indiana extends back more than a quarter-century, beginning shortly after he moved from New York to the island of Vinalhaven in 1978. Its 1982 exhibition, *Indiana's Indianas*, celebrated the artist's newly-chosen residency in Maine by showing works from his own collection housed in The Star of Hope, the former lodge of the International Order of Odd Fellows Indiana acquired as his new home and studio. The current exhibition, *Robert Indiana and the Star of Hope*, is also drawn almost exclusively from Indiana's collection, but it reexamines his career in far more expansive fashion. Distinguished historian and curator of American art, John Wilmerding, explores Indiana's career in the broader context of the larger body of work the artist has created since his arrival on Vinalhaven, and in comparison with the careers of the other artists of the Pop Art movement with which Indiana was associated. My own essay delves into the history of the Odd Fellows and particularly that of the Star of Hope Lodge, since 1982 listed on the National Register of Historic Places. What emerges is a picture of how Indiana has engaged in an ongoing dialogue with his immediate surroundings, transforming the Star of Hope into what I believe is one of the most distinctive artist home and studio environments of the twentieth, and now twenty-first, century.

The Farnsworth's presentation of *Robert Indiana and the Star of Hope* is a product of a dynamic partnership of people and organizations. The financial underpinnings for the exhibition and its catalogue have been provided by a grant from The National Endowment for the Arts, a federal agency; and by donations from Mrs. F. Eugene Dixon; Morgan Art Foundation, who are also lenders to the exhibition; and Gillian and Simon Salama-Caro. Published by the Farnsworth Art Museum, this catalogue is being distributed by Yale University Press. Dale Schierholt's film, *A Visit to the Star of Hope: Conversations with Robert Indiana,* brings the artist to the world in yet another meaningful way. In addition, the museum is especially pleased to be able to present Robert Indiana with the Maine in American Award, given annually in recognition of the contributions of an individual or group to Maine's role in American art.

Thanks are due to many who have contributed to carrying out what has been a logistically demanding project. Former director Lora Urbanelli championed this exhibition from the beginning, engaging both Robert Indiana and John Wilmerding in carrying out the museum's ongoing mission to celebrate Maine's role in American art. Melissa Ryan and the rest of Robert Indiana's staff at the Star of Hope have assisted with documenting and preparing the artist's works for transportation to the museum. Simon Salamacaro, who is preparing the catalogue raisonné of Indiana's work, has been a steadfast supporter, helping to secure loans from Morgan Art Foundation as well as assuring accurate descriptions of the works in the exhibition. The project also benefited enormously from the participation of John Wilmerding, my long-time friend and colleague, who shared in the selection of objects. The installation of Indiana's *EAT* sculpture on the roof of the museum, its first public display since appearing at the 1964 World's Fair in New York, was no small feat. Burr Signs of Yarmouth, Maine, designed the structure on which the sculpture is mounted, and Shelley Engineering, Inc., of Warwick, Maine, designed the substantial base to which the sculpture is attached. The fabrication of this base was carried out by Rockport Steel of Rockport, Maine.

Thanks are due to the entire museum staff for carrying out this complex project and all its related components. Special recognition goes to the curatorial staff of Angela Waldron, Jane Bianco, Bethany Engstrom, Robert Colburn and Joyce Houston; to Jim Wilson and Aedan Jordan for their assistance with the installation of *EAT* and *LOVE Wall*; and to the catalogue designer, Mary Margaret Sesak. The catalogue's arresting photographs of the interior of the Star of Hope were taken by Walter Smalling.

Finally, I am deeply grateful to Robert Indiana, who offered me and my staff unwavering hospitality on our many visits to Vinalhaven over the past three years. It has been a privilege to work with him. He is an artist whose career consistently evidences a deep commitment to exploring the relationship between the events of his own life and the events of American life that have unfolded around him. His work has integrity and power, integrating as it does through his subjects the profoundly personal with the profoundly universal. This very integration gives his work a seriousness and depth that takes it beyond the realm of Pop Art. Over a span of nearly fifty years, he has taken us from *LOVE* to *HOPE*, examining the fabric of American culture and how our own lives are part of it. For this and for much more, Robert Indiana's contributions stand among the most important in the history of American art, rewarding all those who engage it, now and for generations to come.

Hero, c. 1934, crayon and pencil on paper; 8 1/4 x 11 ins.;
collection of the artist

ROBERT INDIANA
AND THE STAR OF HOPE

On the occasion of the exhibition at the
Farnsworth Art Museum, Rockland, Maine
June 20–August 25, 2009

Cover image:
Robert Indiana, *HOPE*, 2008, oil on canvas, 36 x 36 ins., collection
of the artist, ©Artists Rights Society (ARS), New York

All art work unless otherwise noted by Robert Indiana ©2009 Morgan
Art Foundation/Artists Rights Society (ARS), New York

Photos:
Unless otherwise indicated, interior Star of Hope photos by Walter
Smalling; artwork photographed by Steve Morrison

IBSN: 978-0-300-15470-2
Library of Congress Control Number: 2009923647

Designer: Mary Margaret Sesak
Printer: J.S. McCarthy Printers

Fonts: Optima, Adobe Garamond
Paper: Chorus Art Gloss 100 lb. text and 63 lb. cover

Distributed by Yale University Press, New Haven and London
www.yalebooks.com

The Farnsworth Art Museum gratefully acknowledges generous support
through gifts and grants for the exhibition, *Robert Indiana and the Star
of Hope*, and its companion catalogue by the following:

• Mrs. F. Eugene Dixon
• National Endowment for the Arts
• Morgan Art Foundation
• Gillian and Simon Salama-Caro